150 MANDALAS Coloring Book for Adults

Stress Relieving Beautiful Mandalas for Relaxation

James Leo

All rights reserved. No part of this book may be reproduced in any form without permission from the author ISBN: 9798649524643

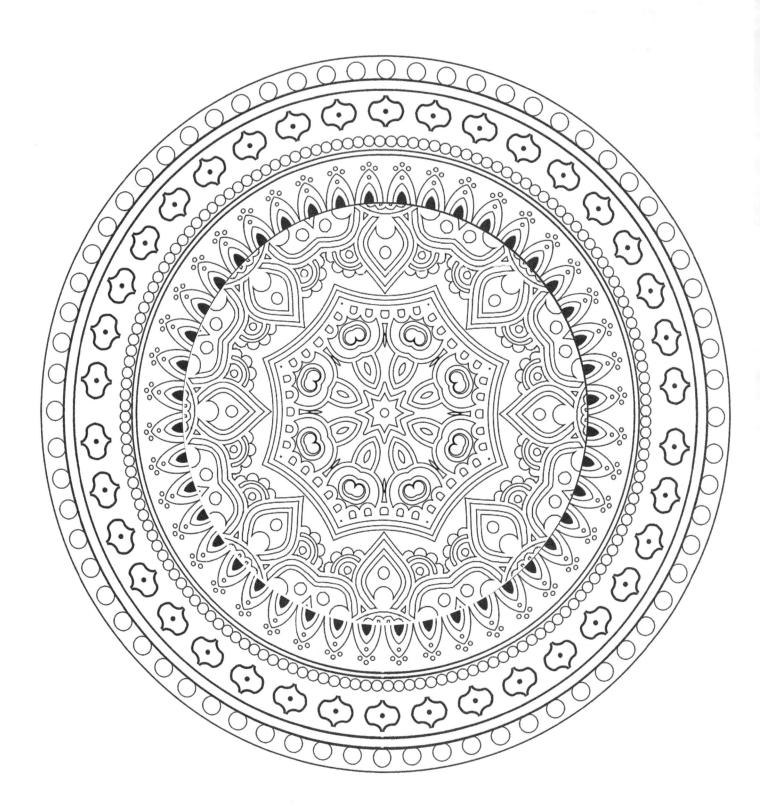

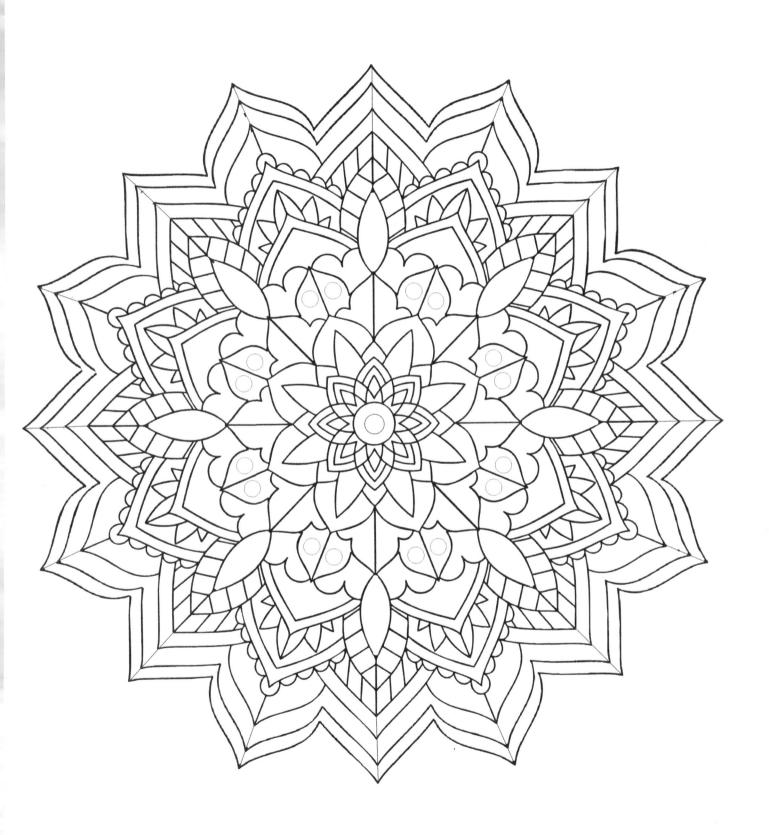

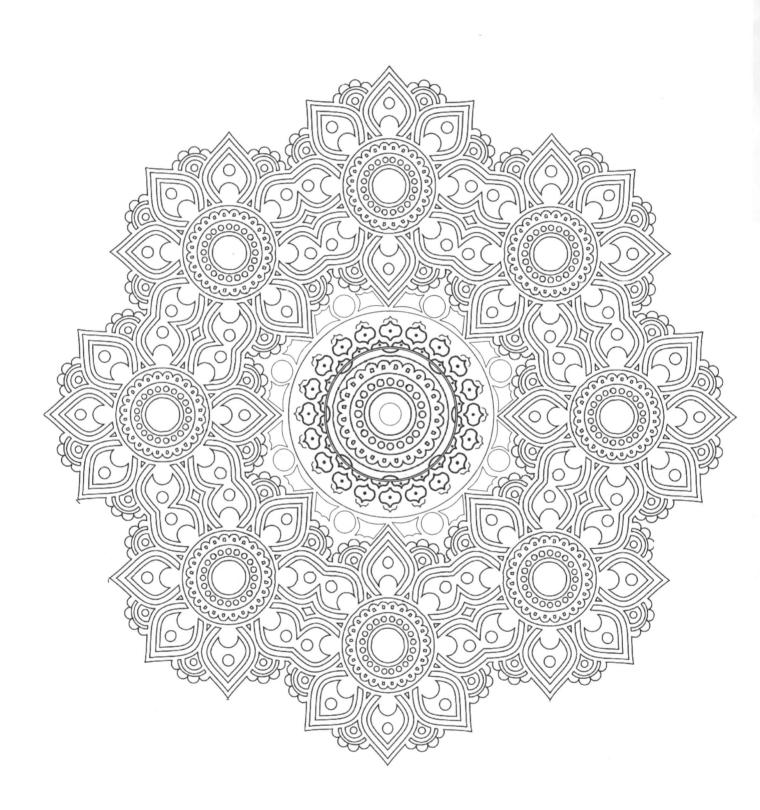

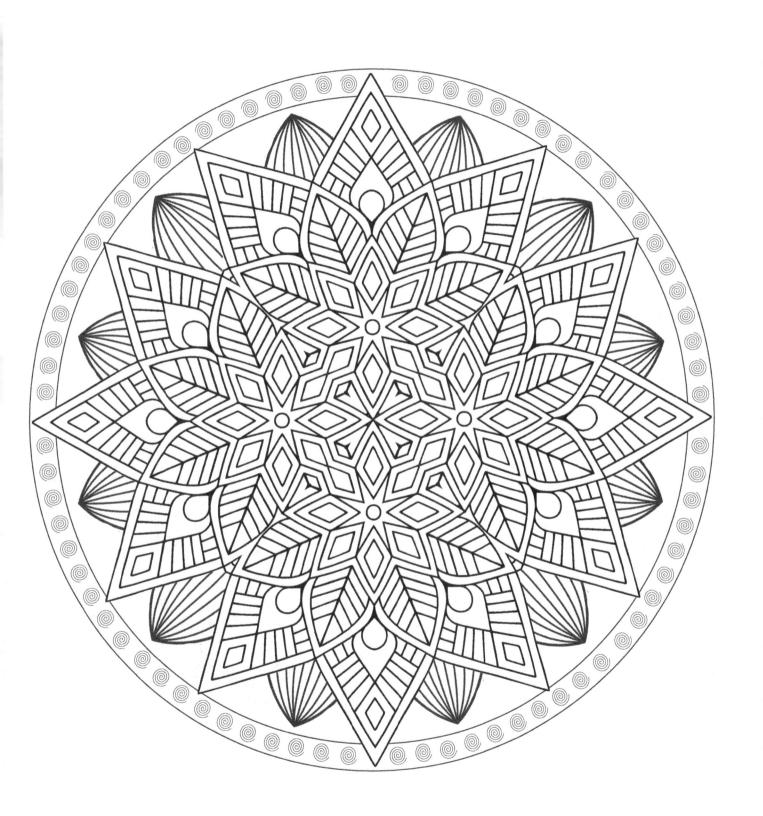

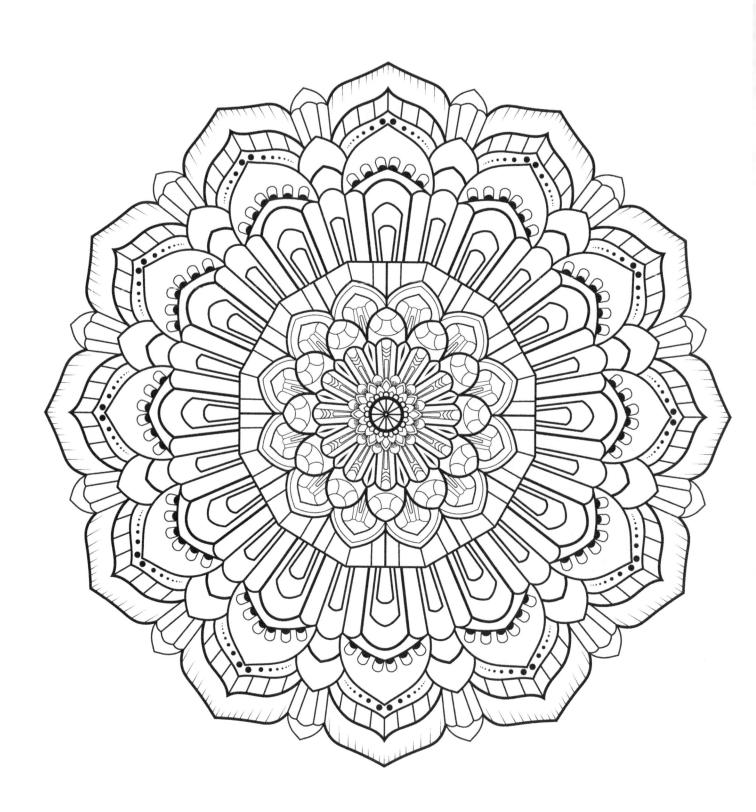

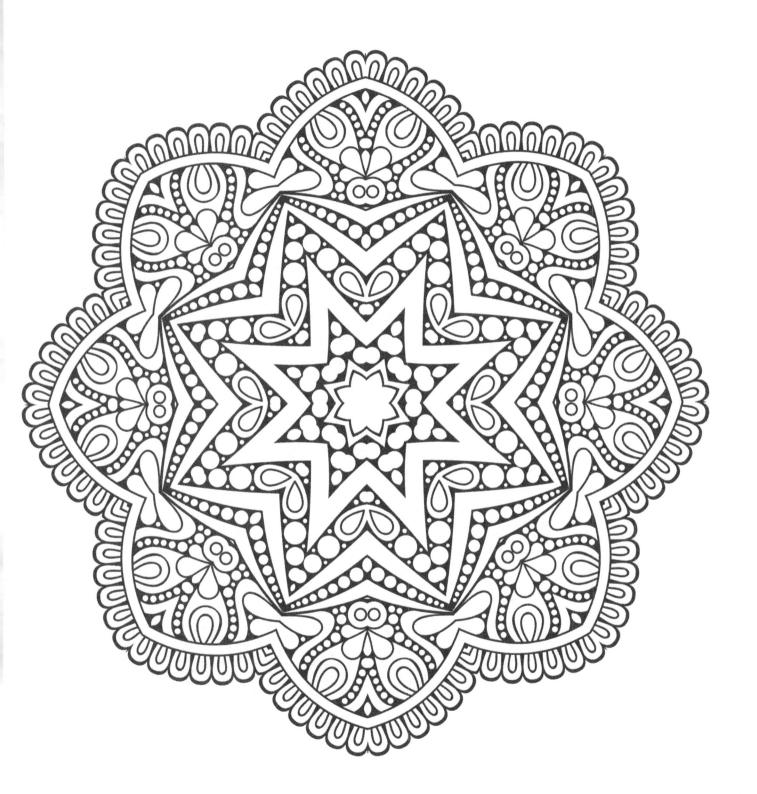

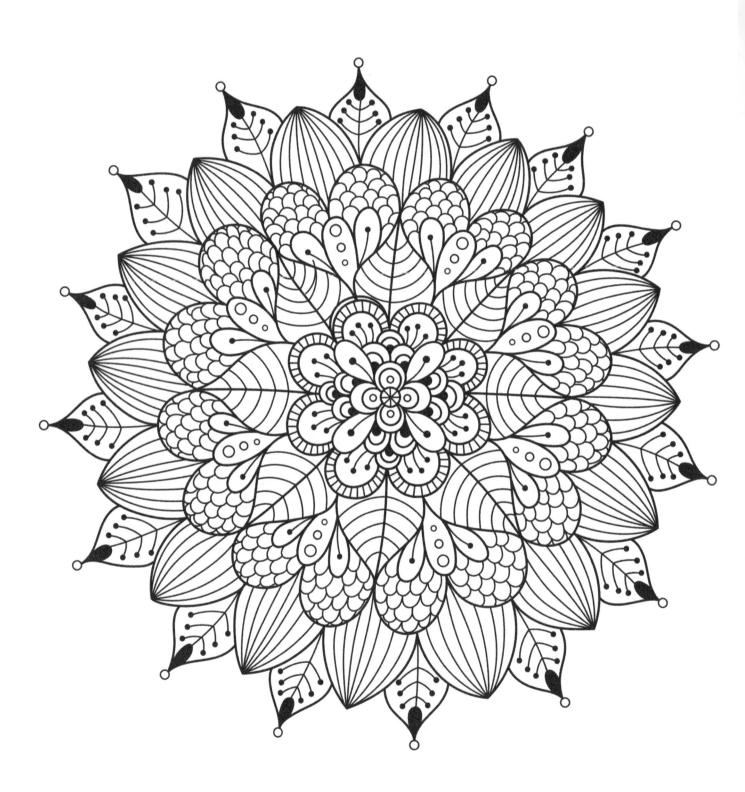

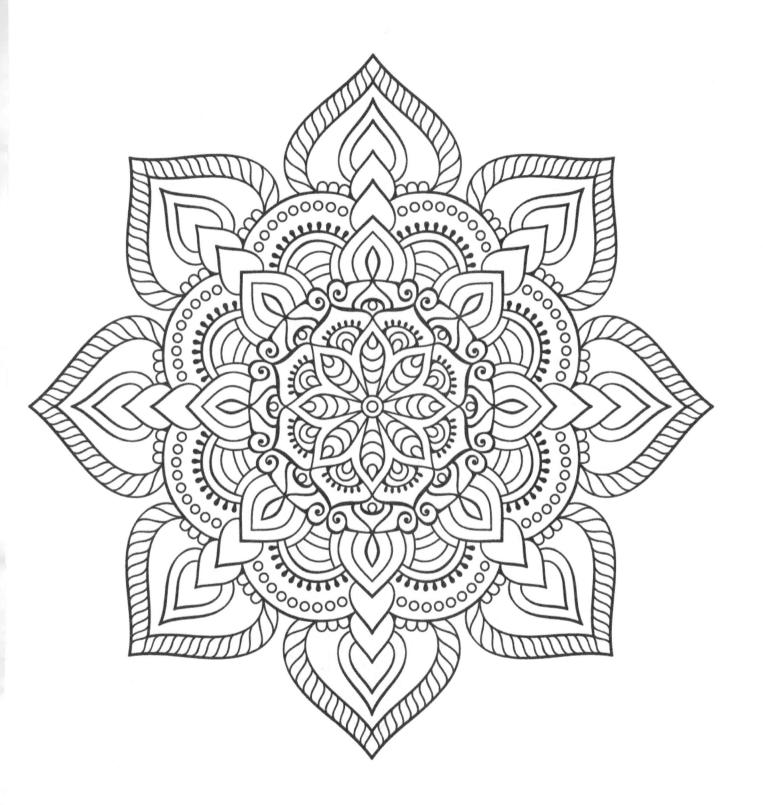

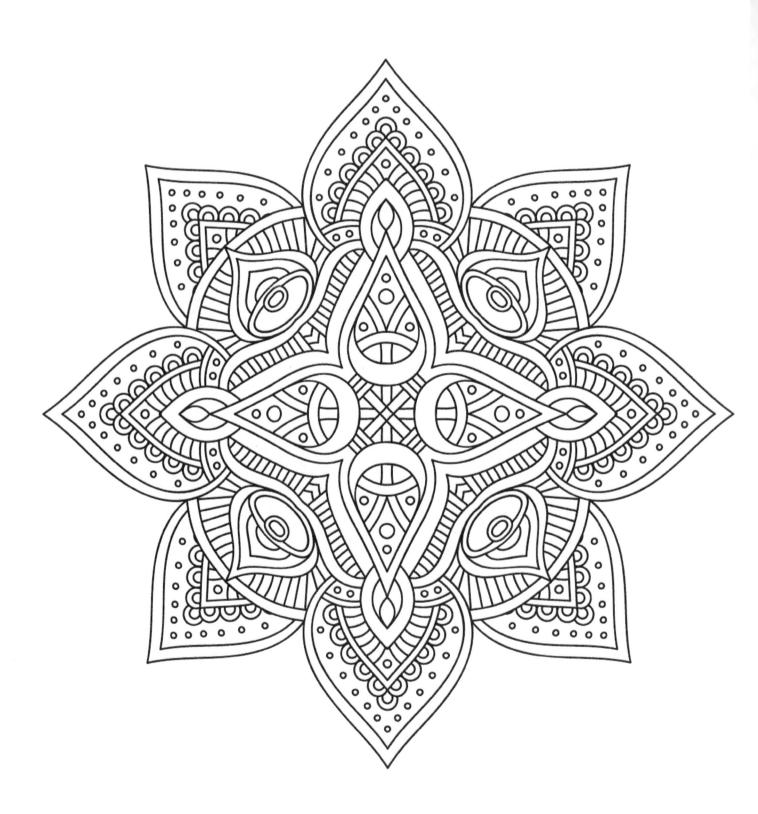

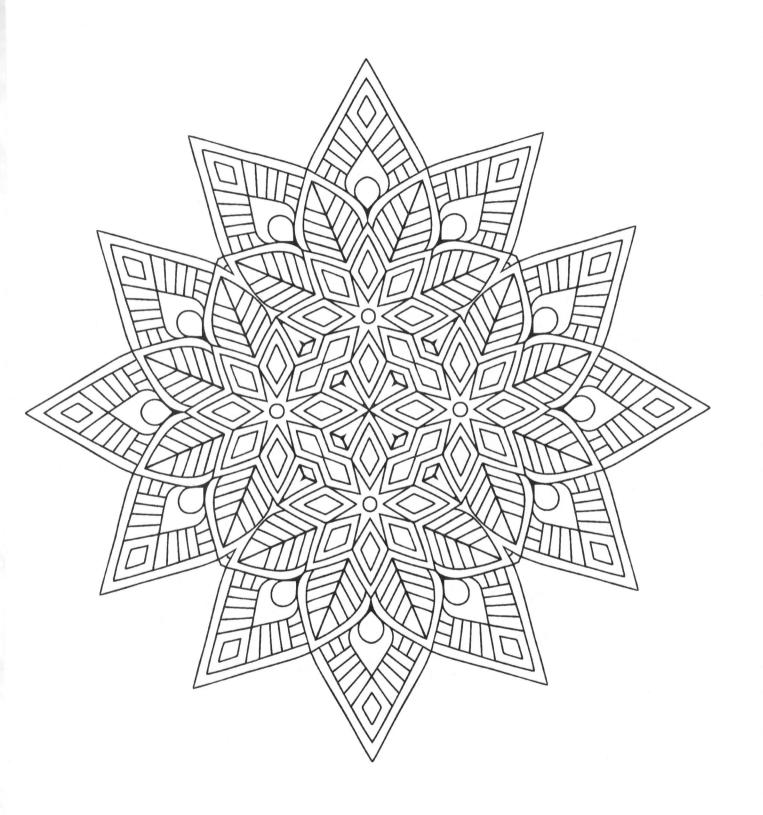

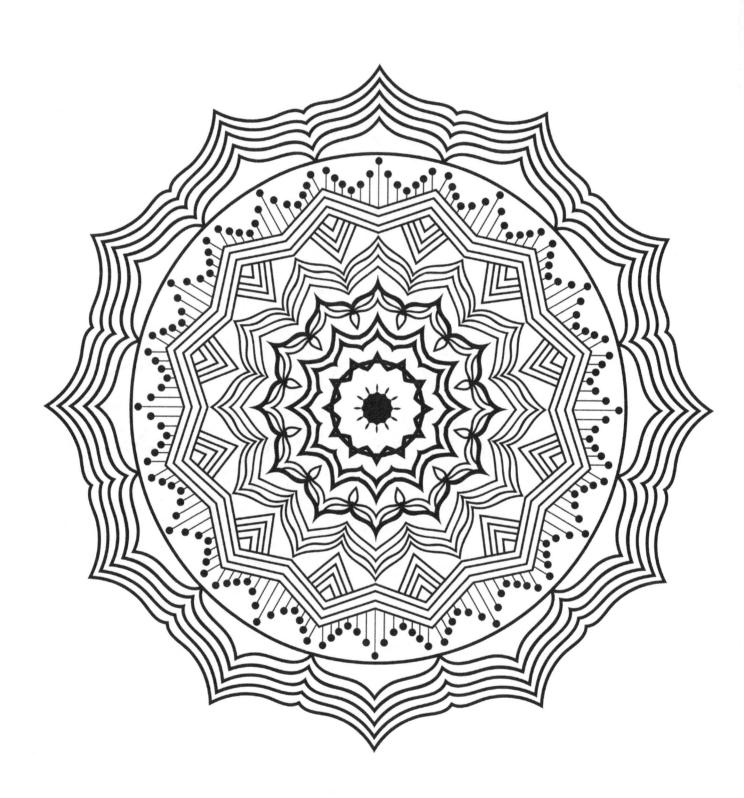

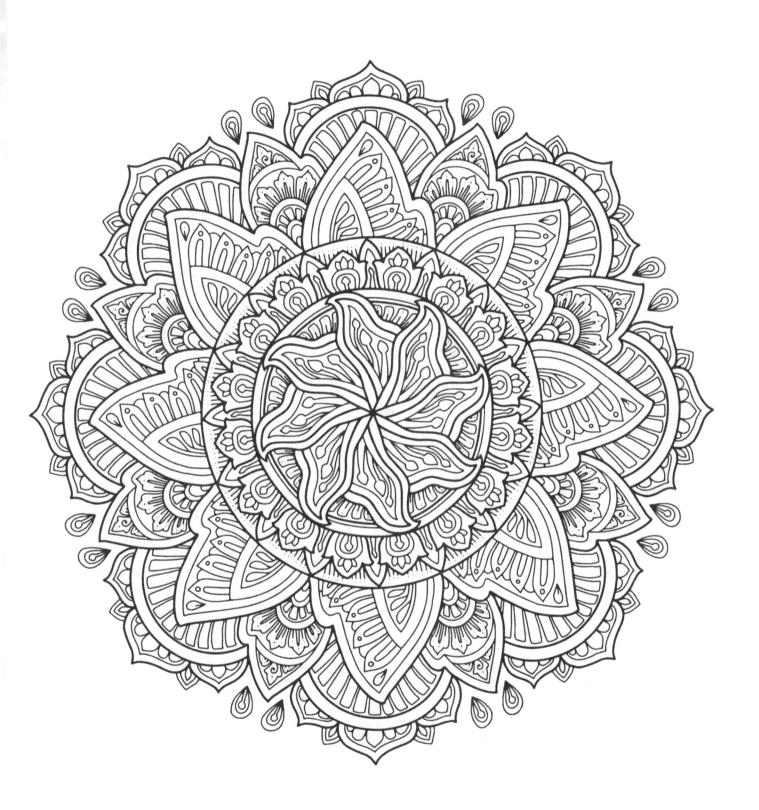

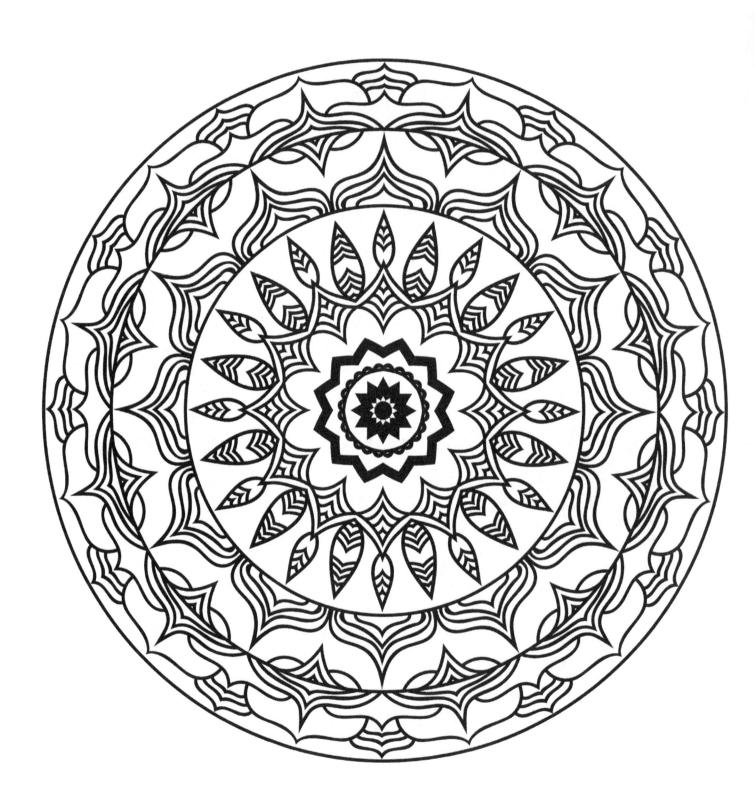

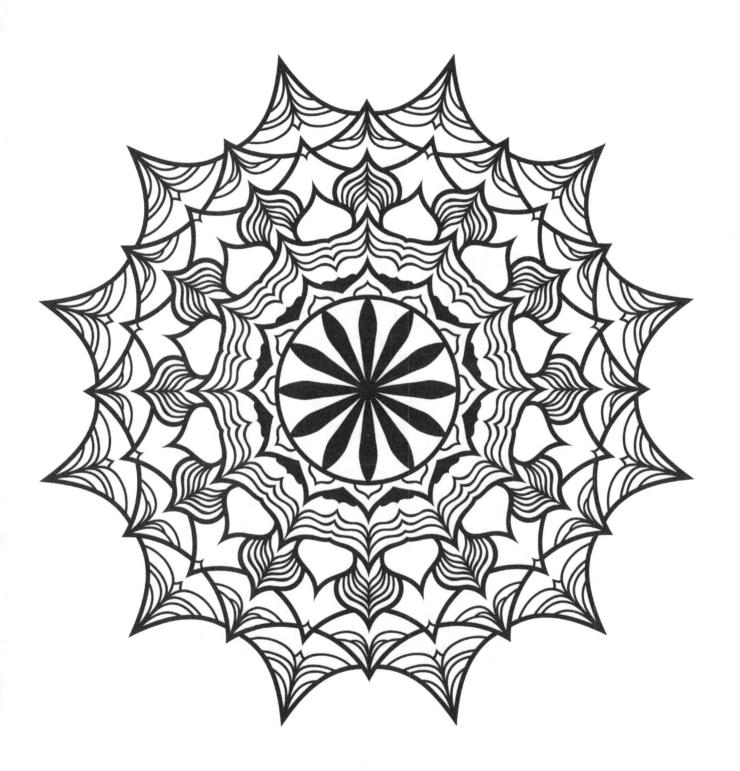

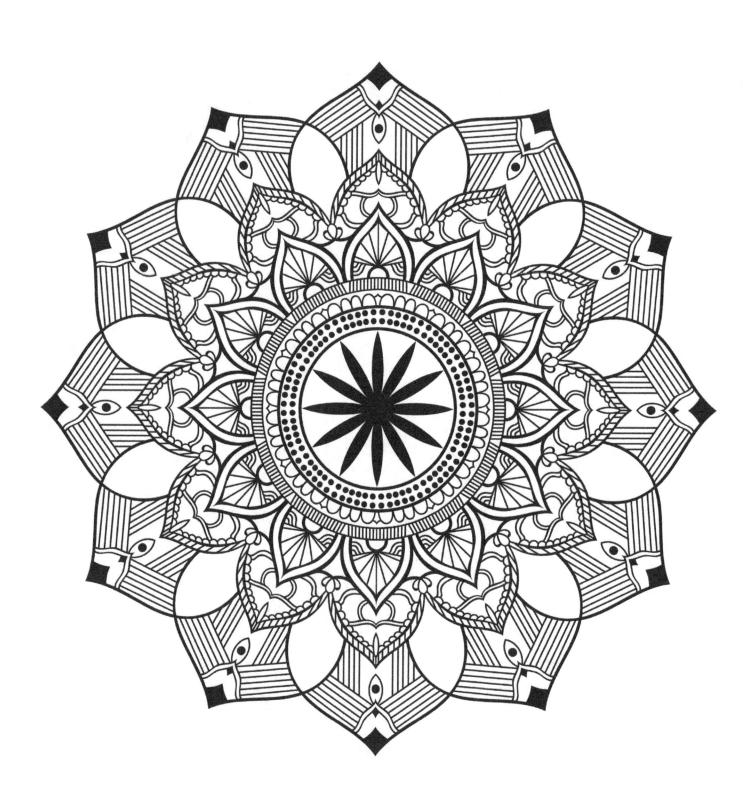

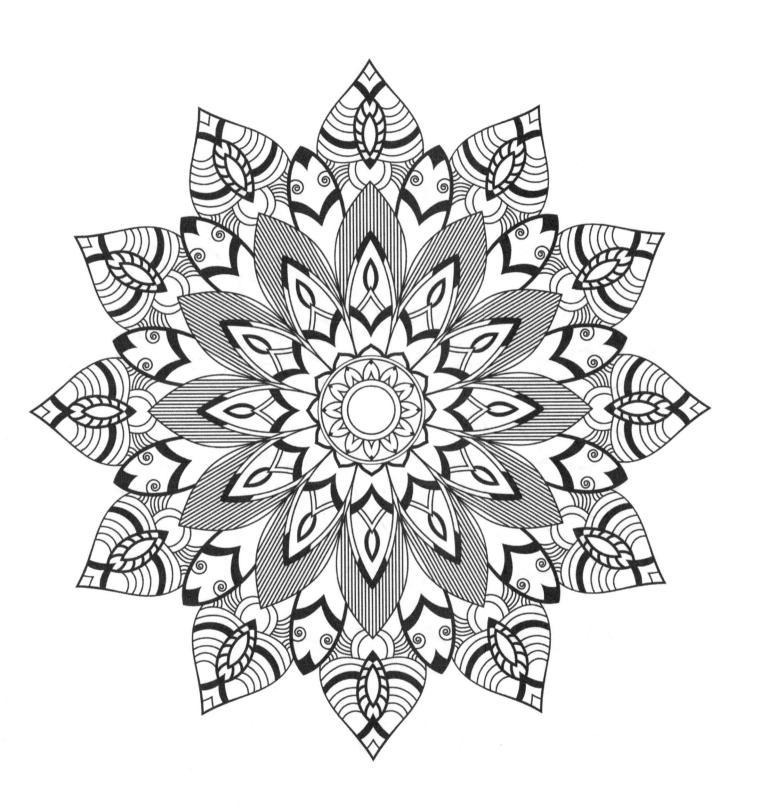

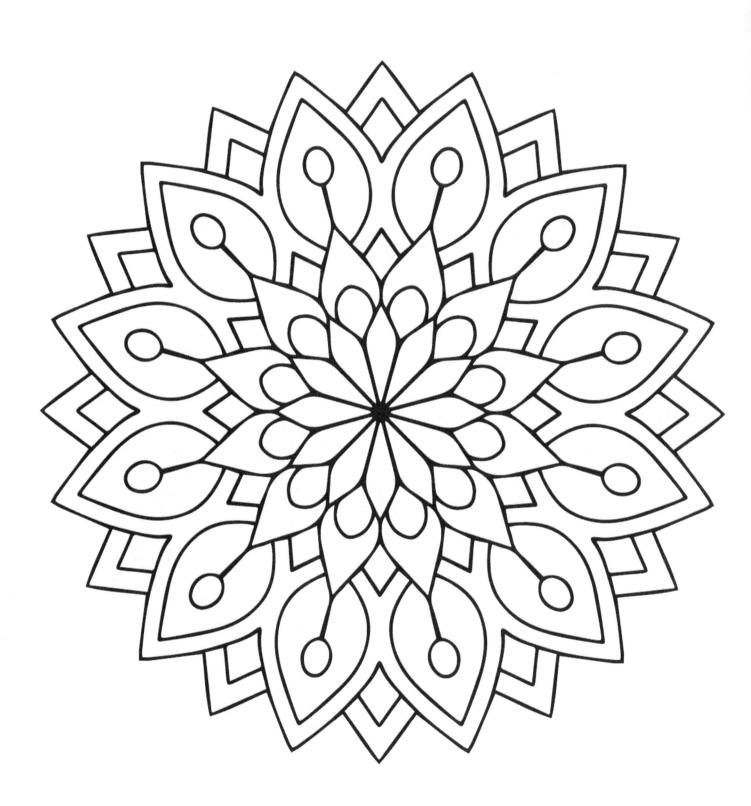

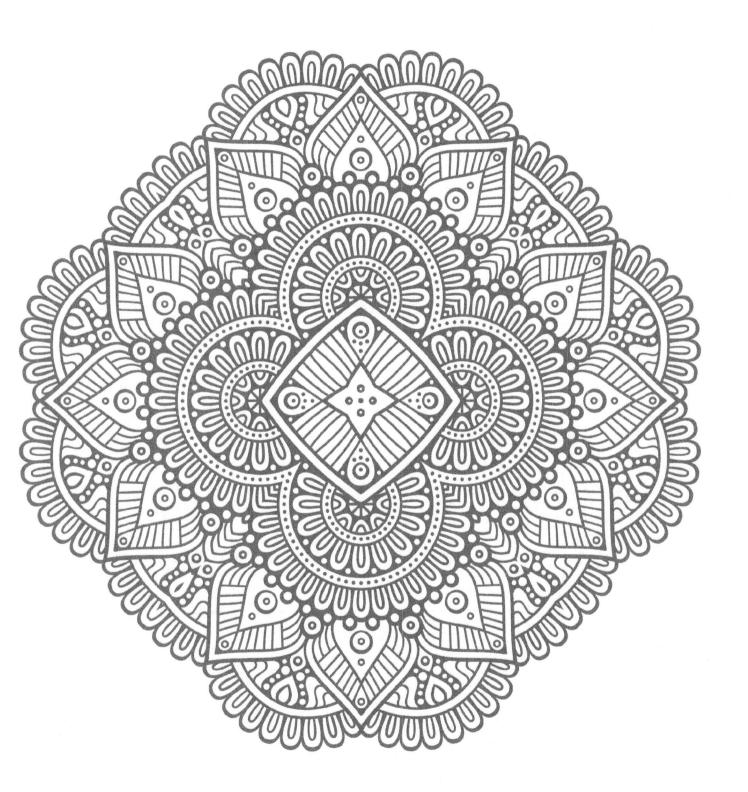

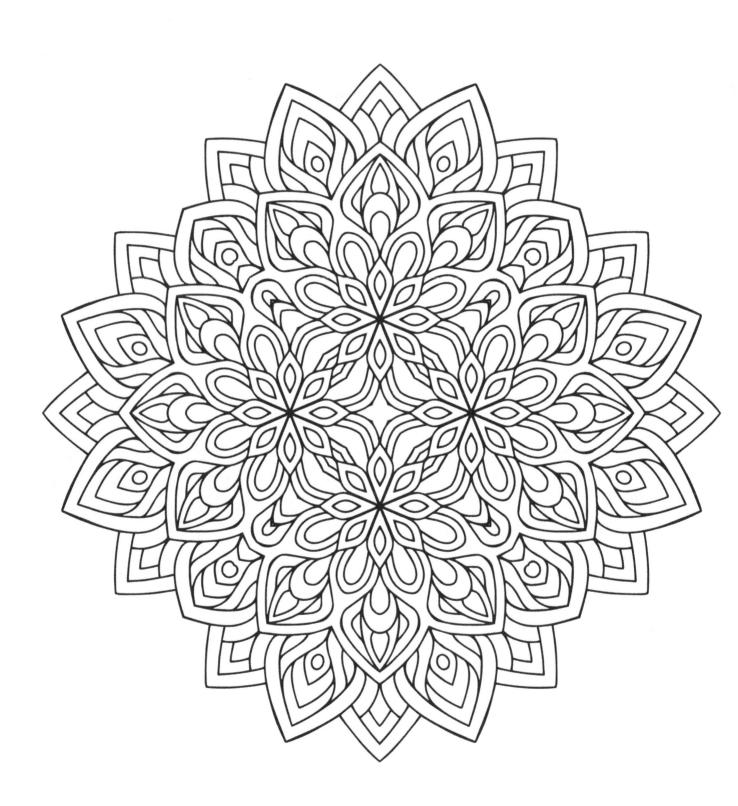

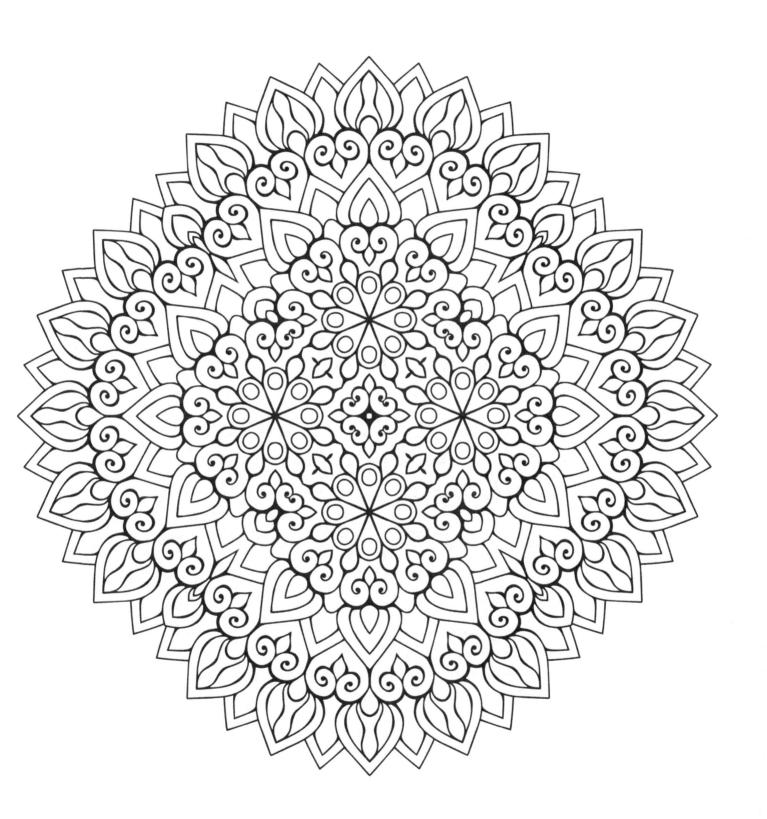

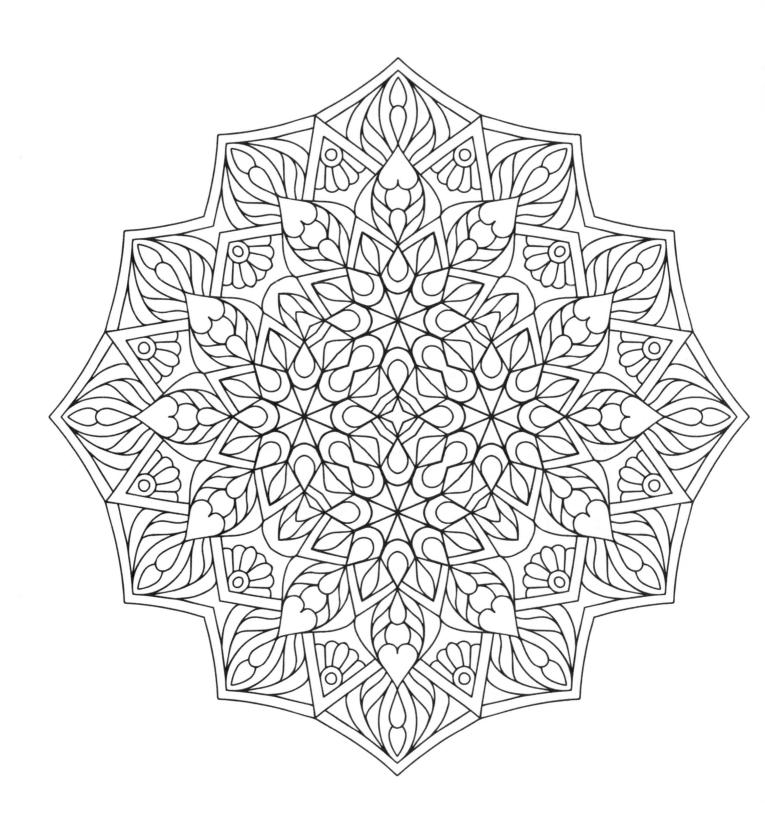

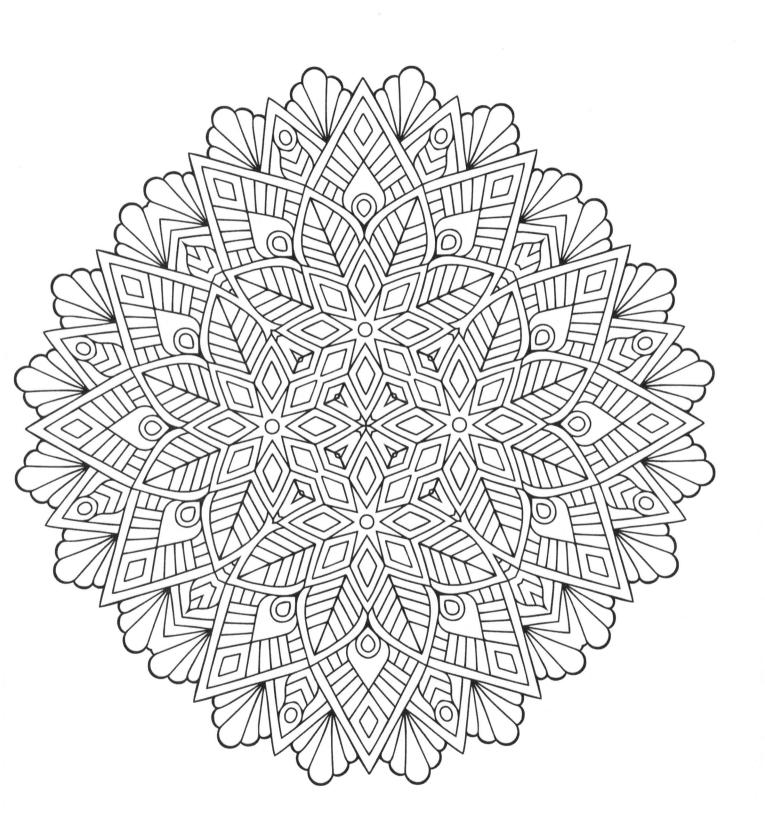

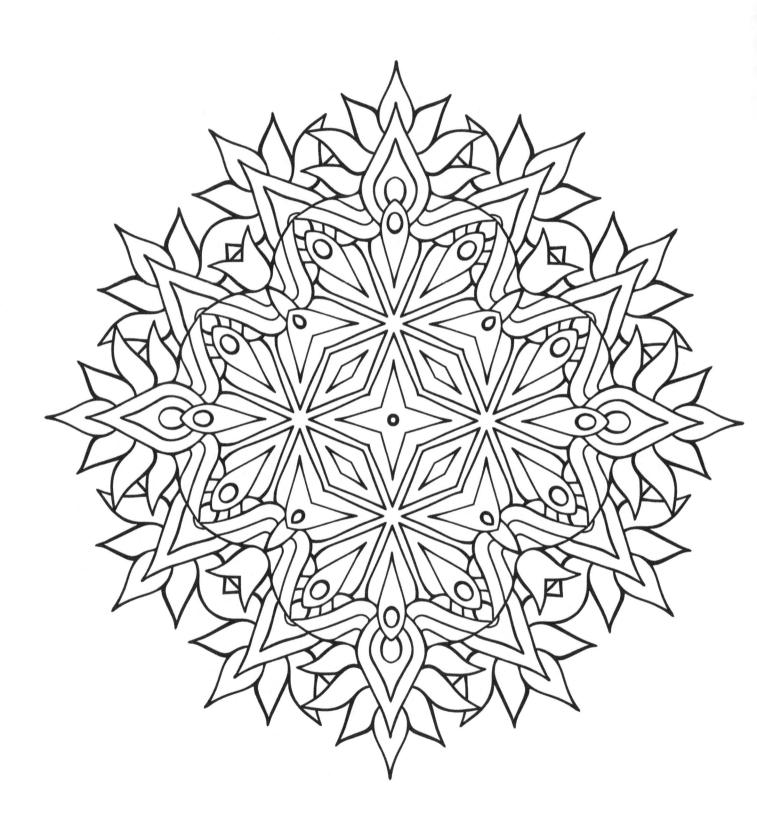

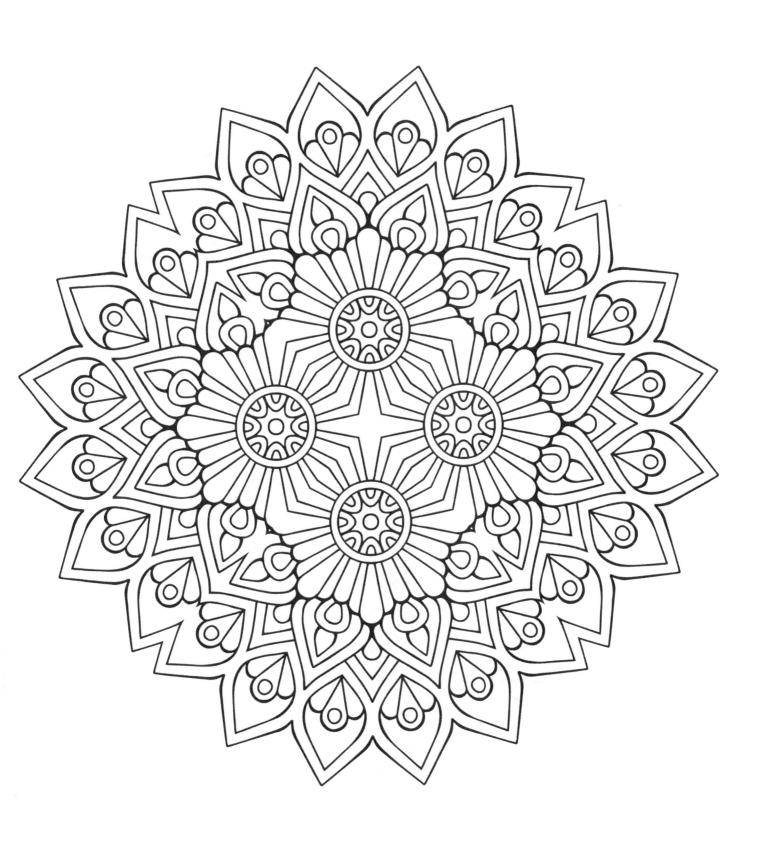

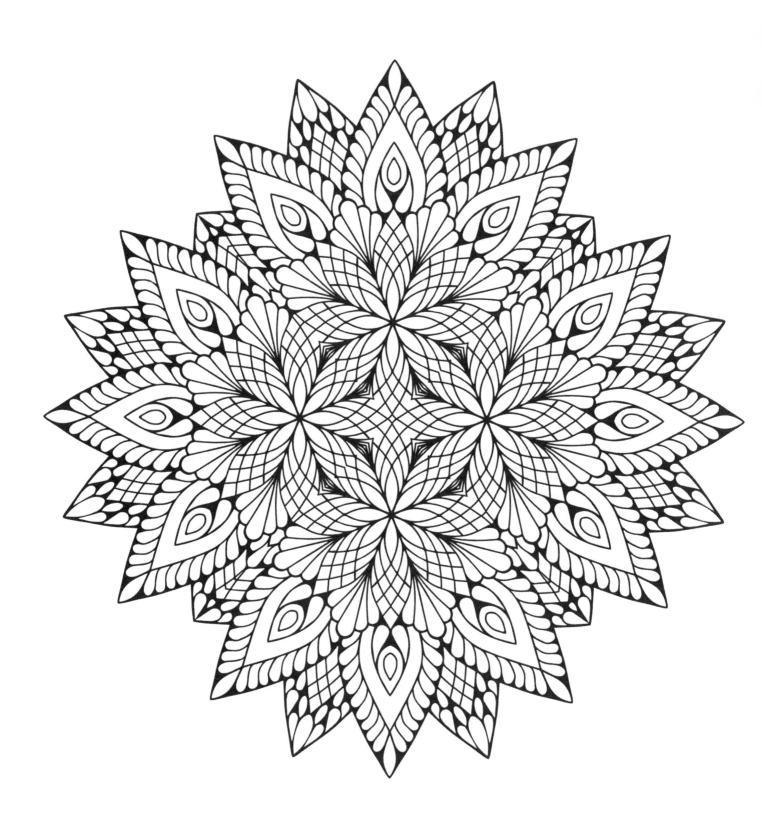

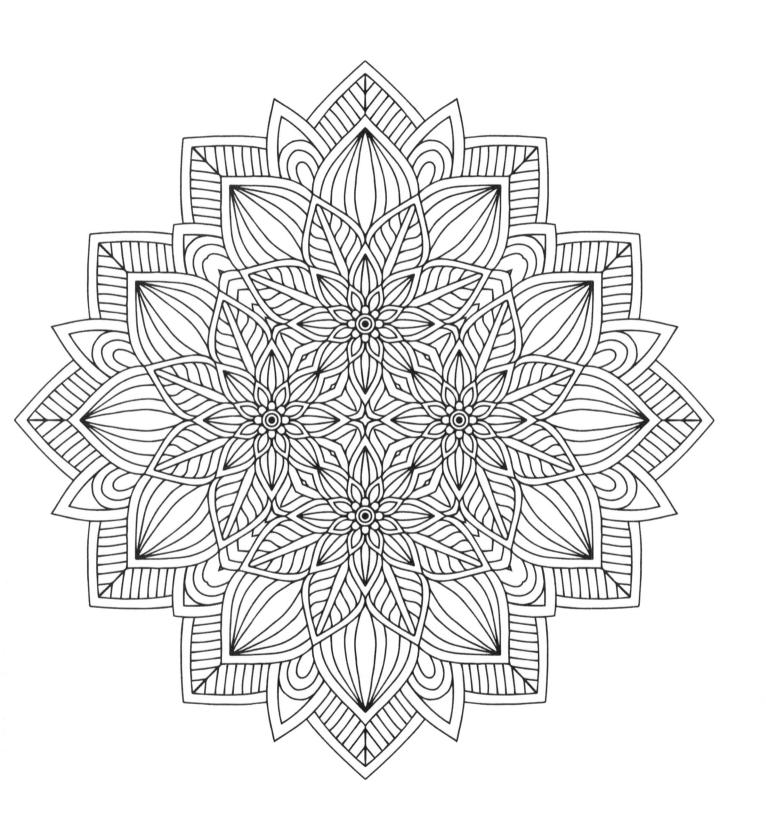

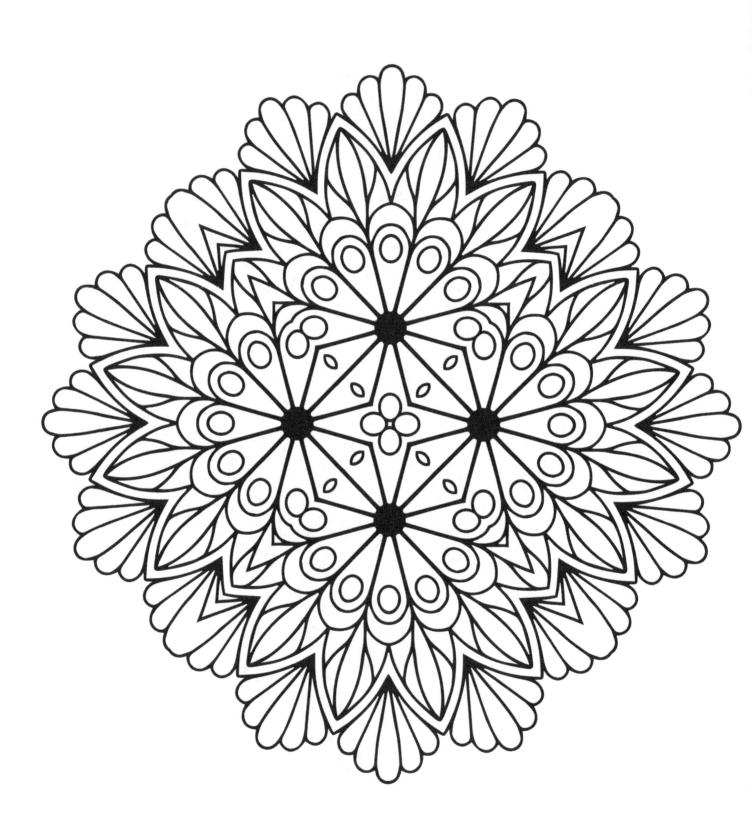

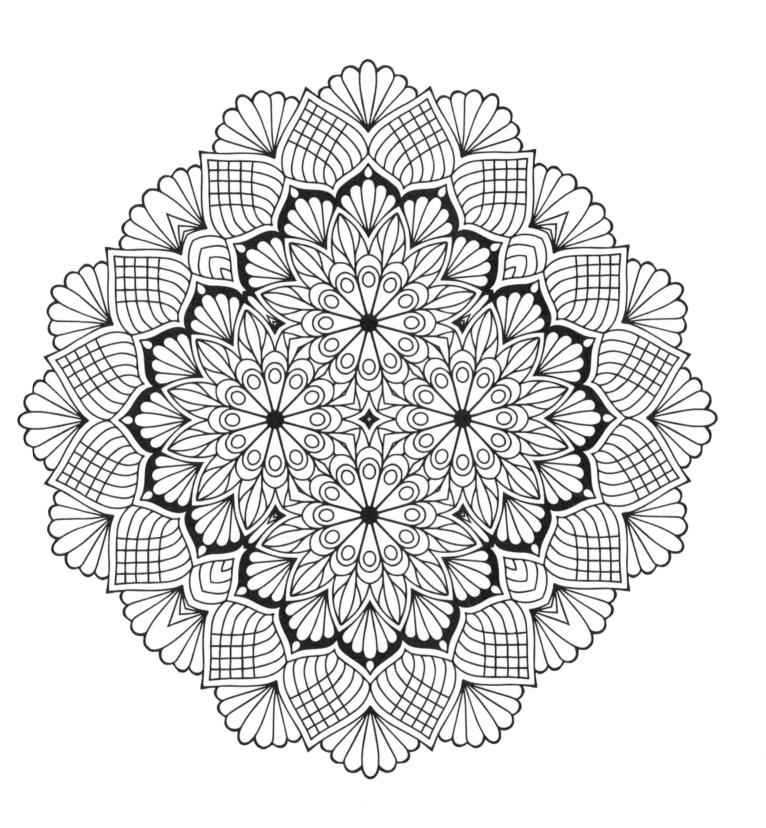

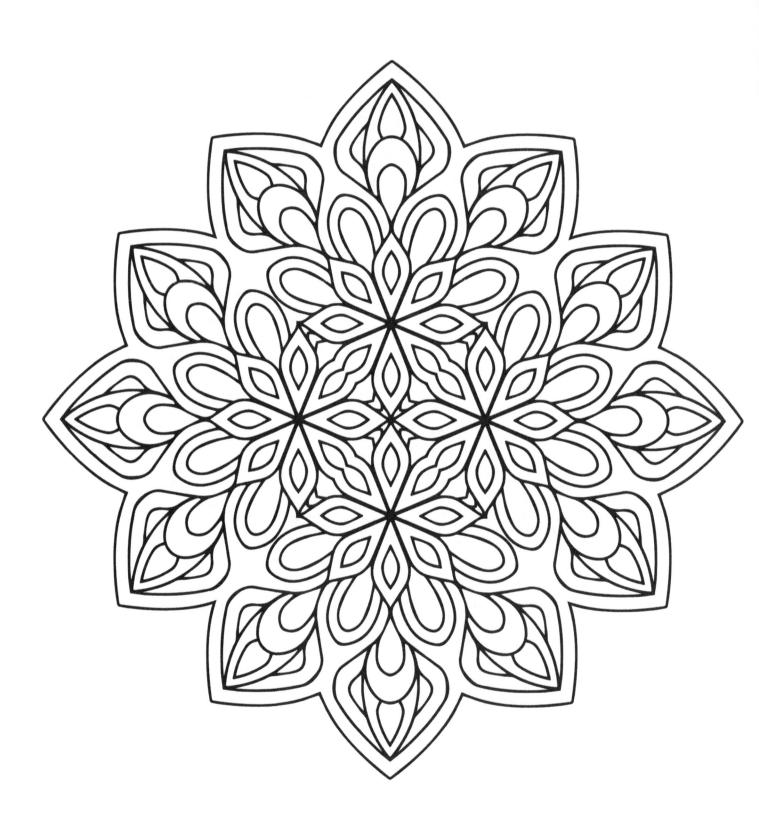

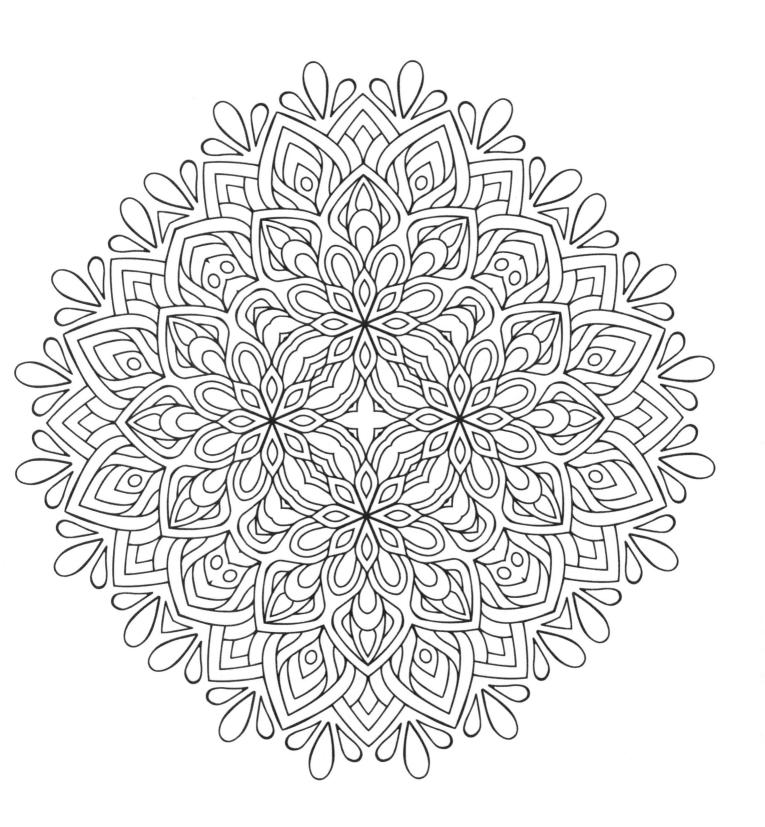

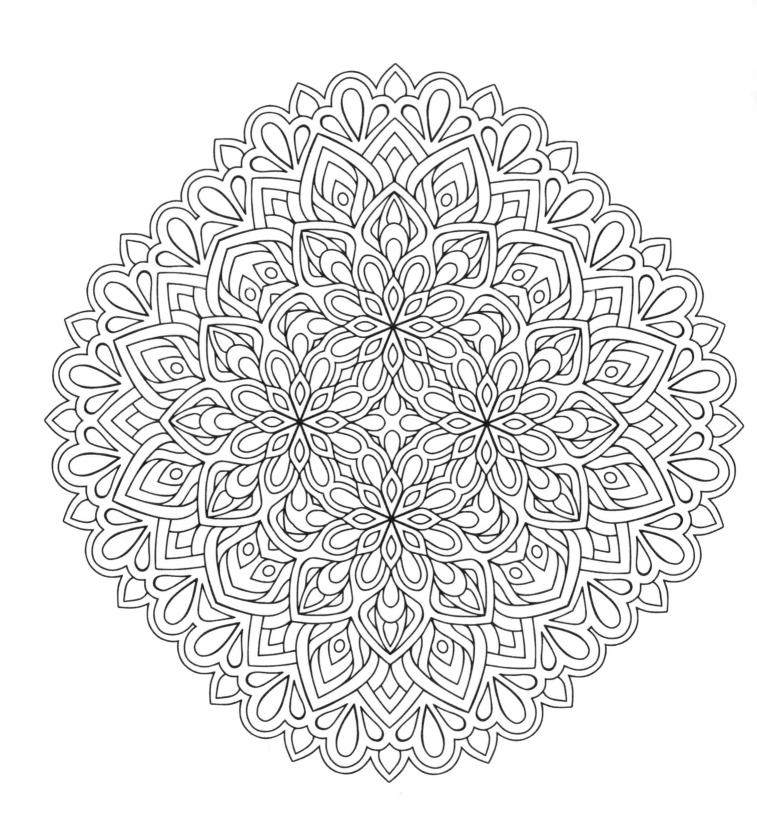

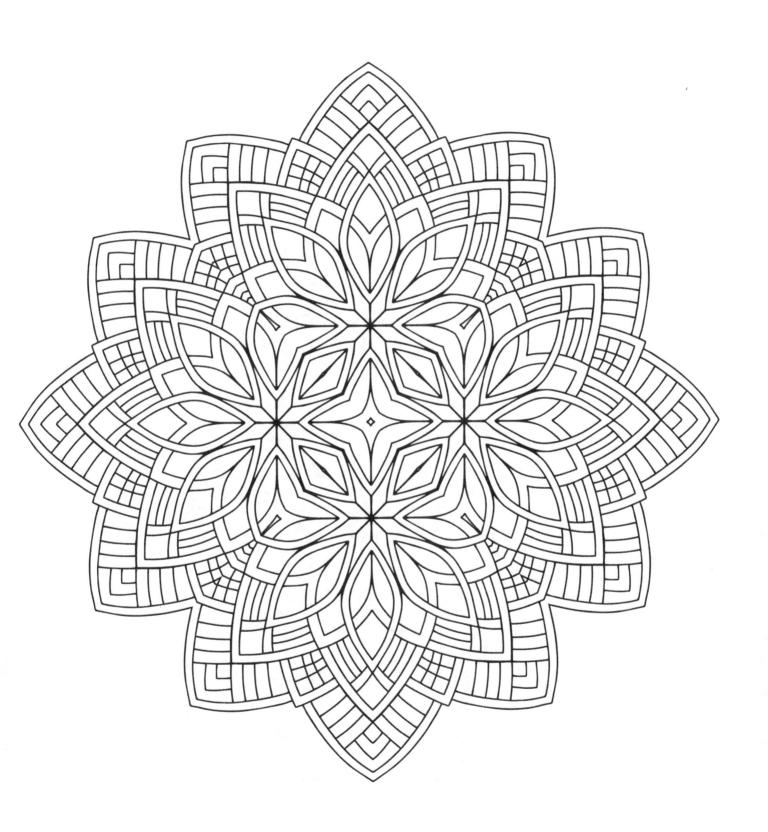

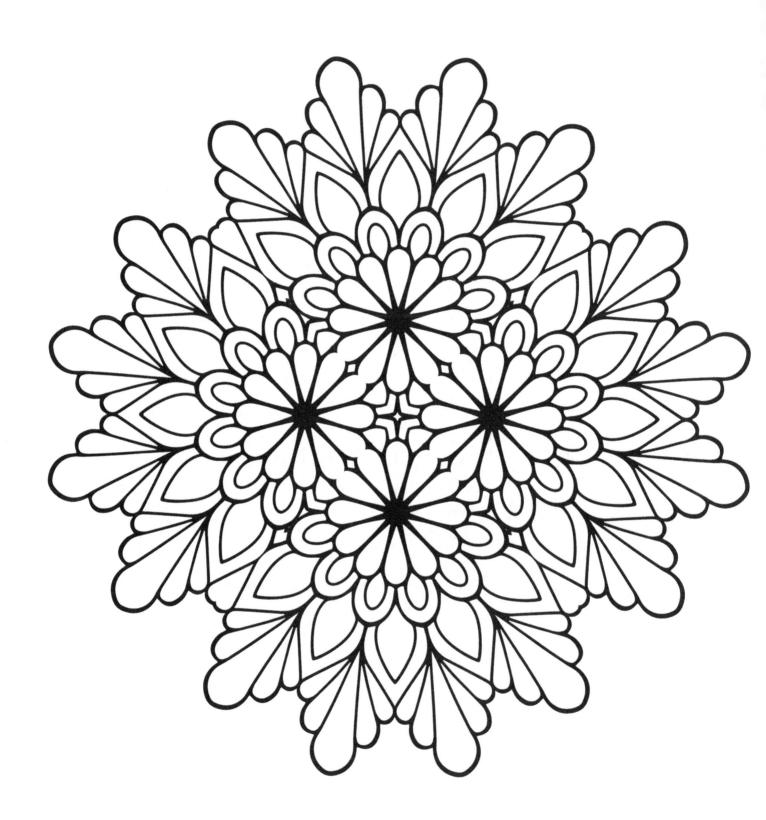

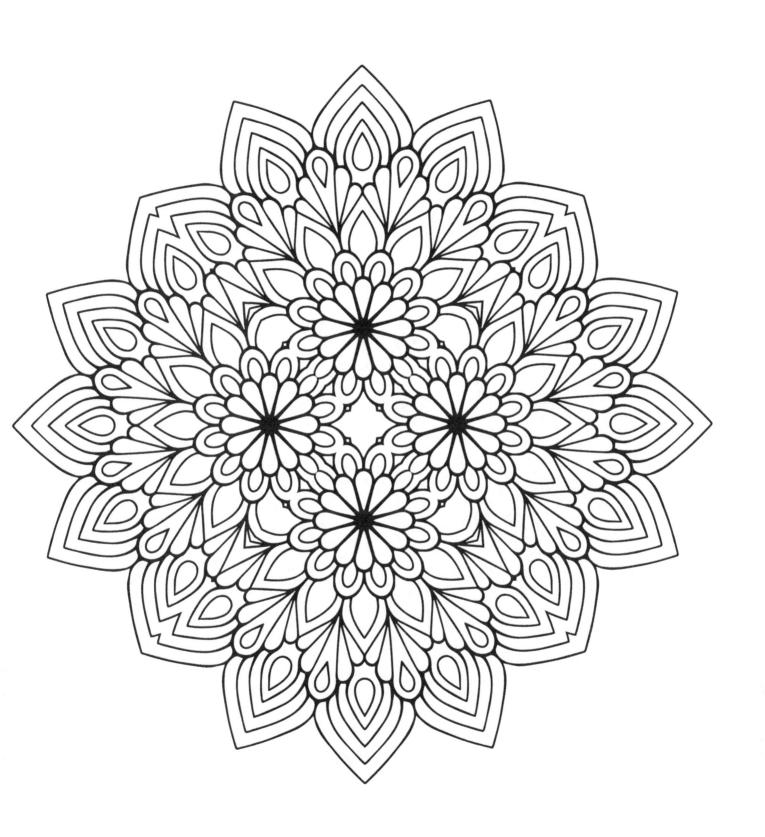

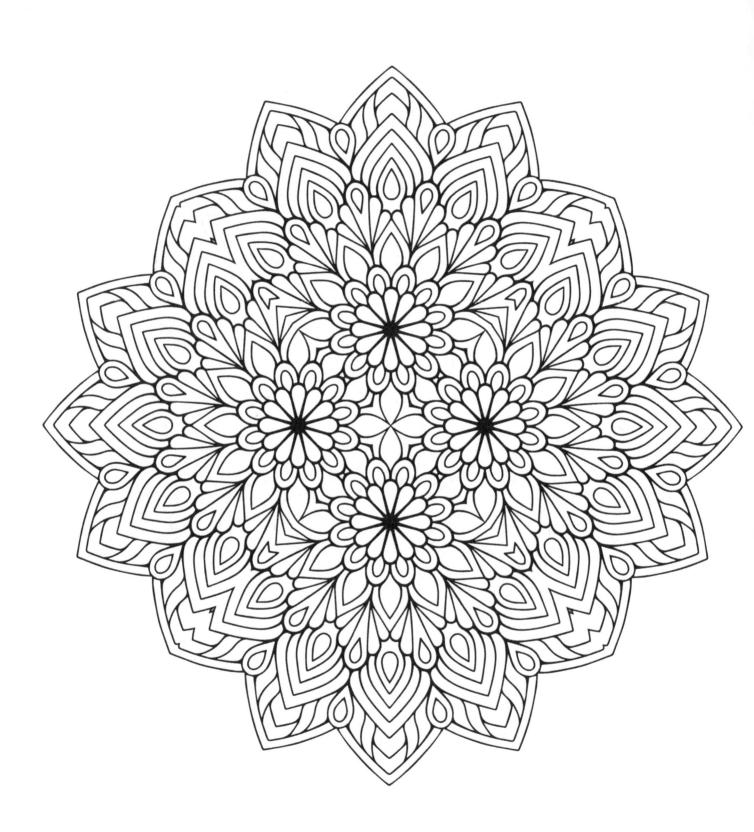

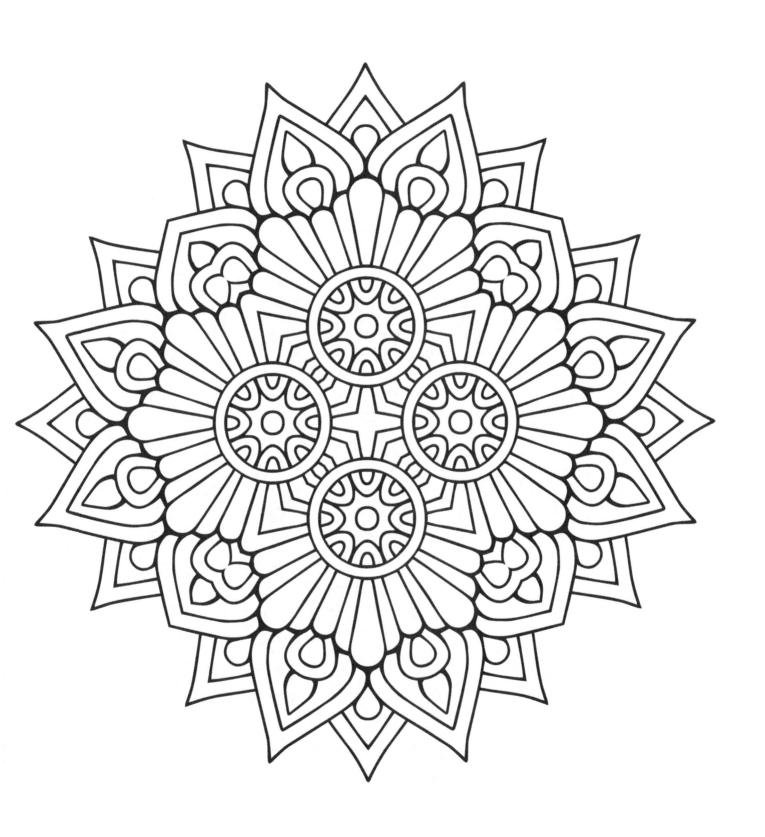

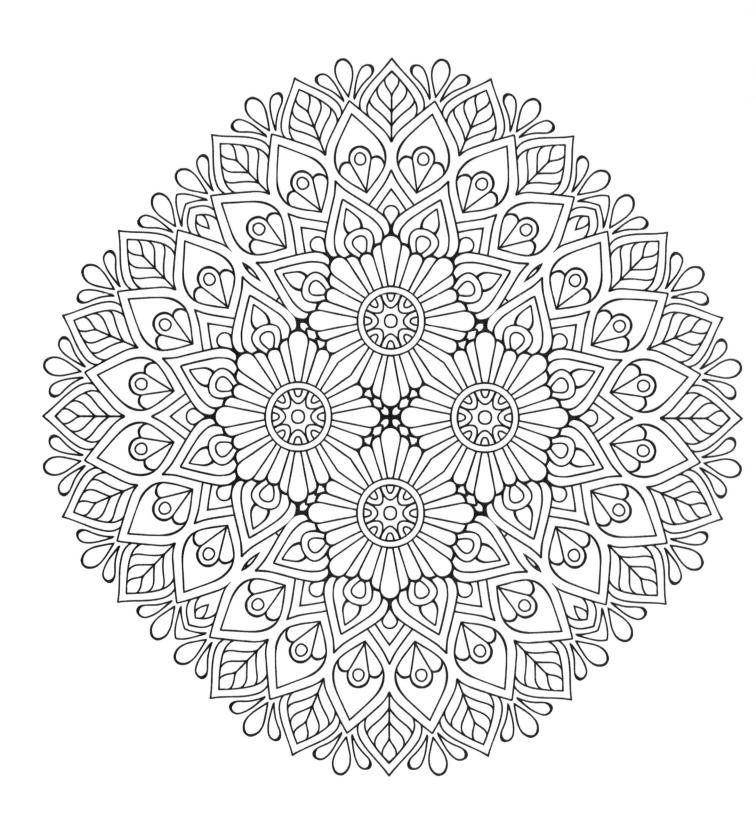

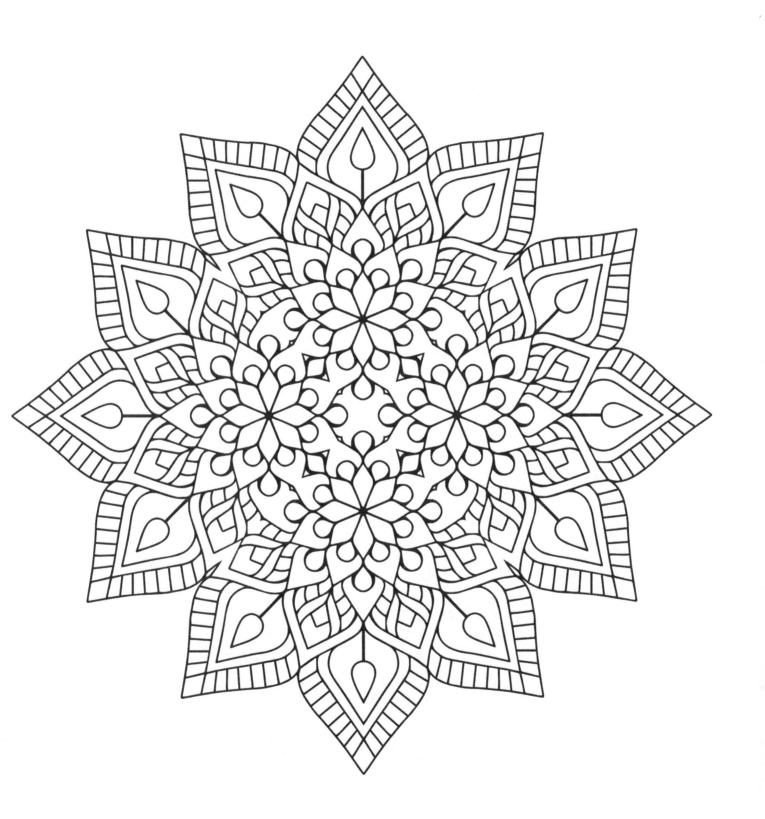

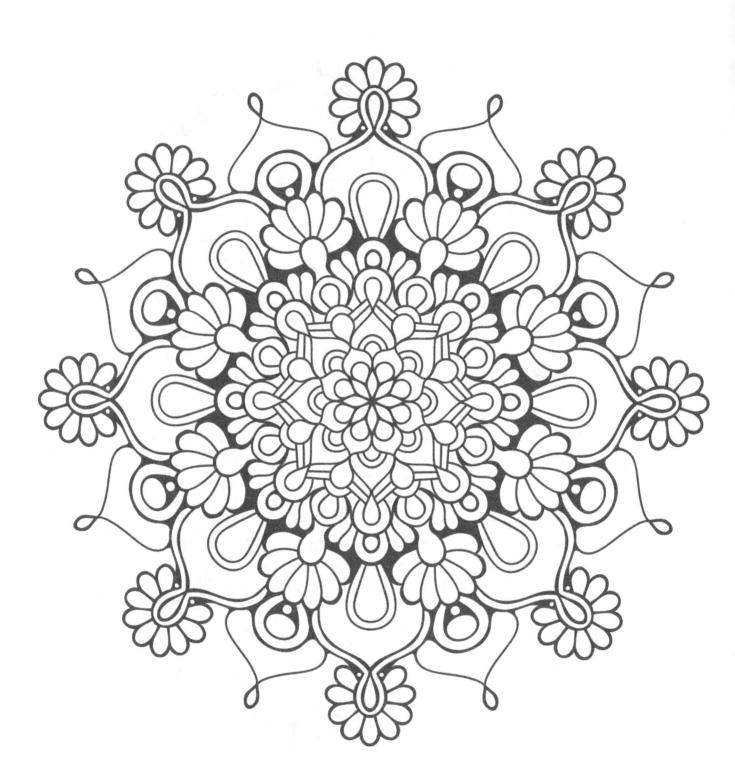

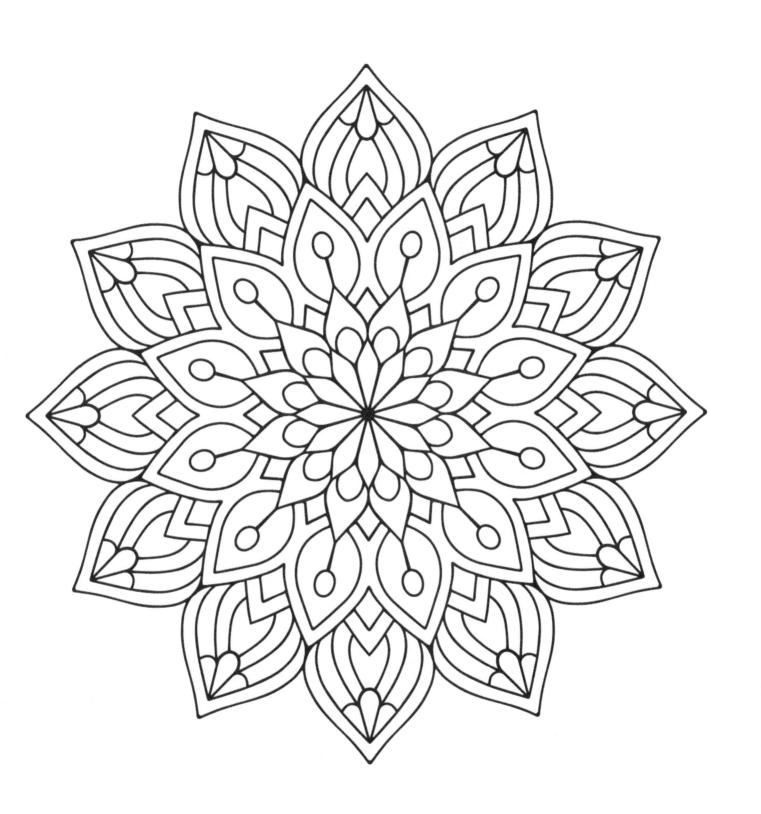

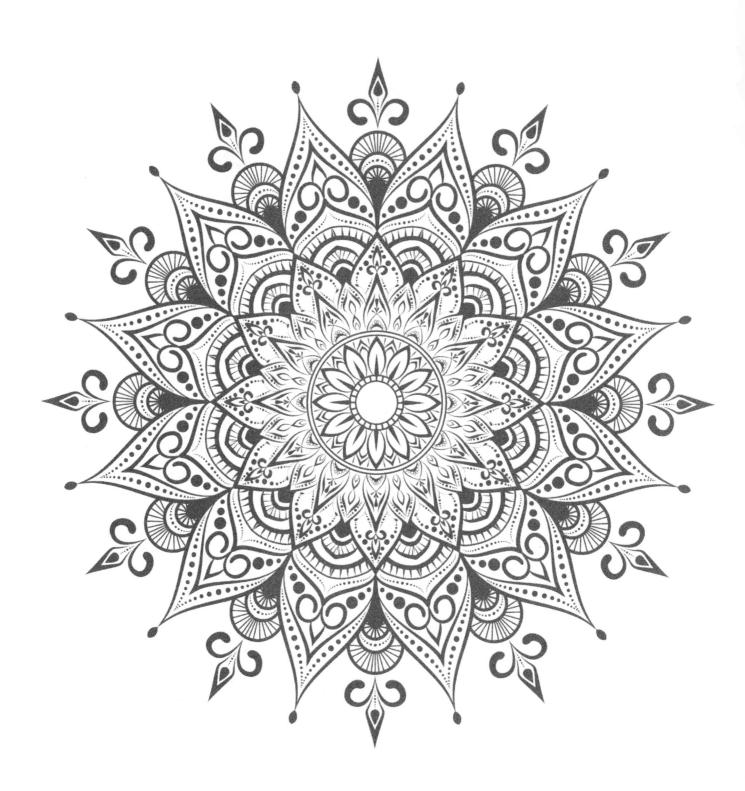

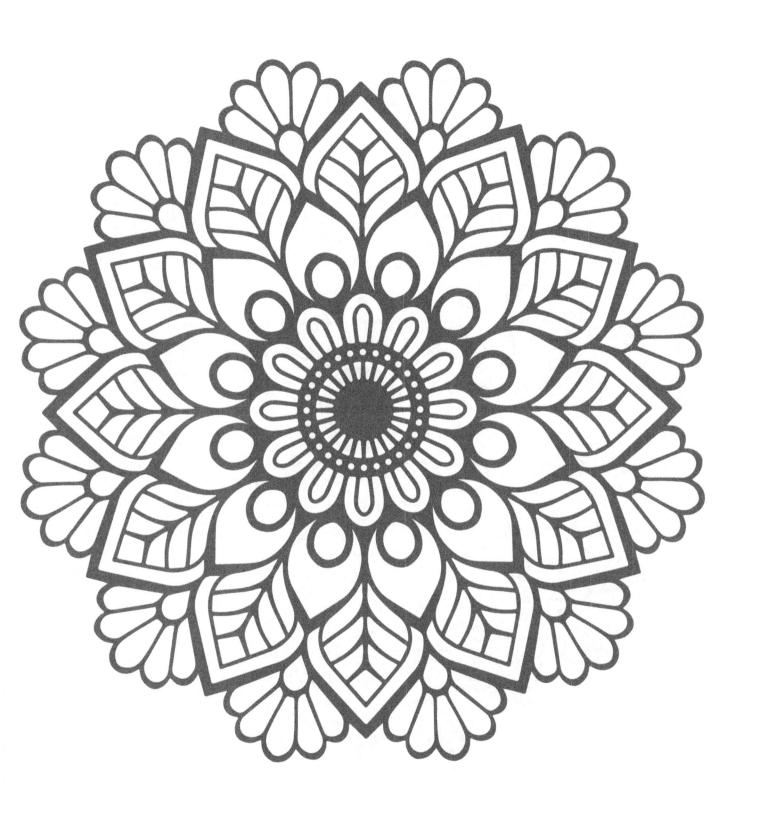

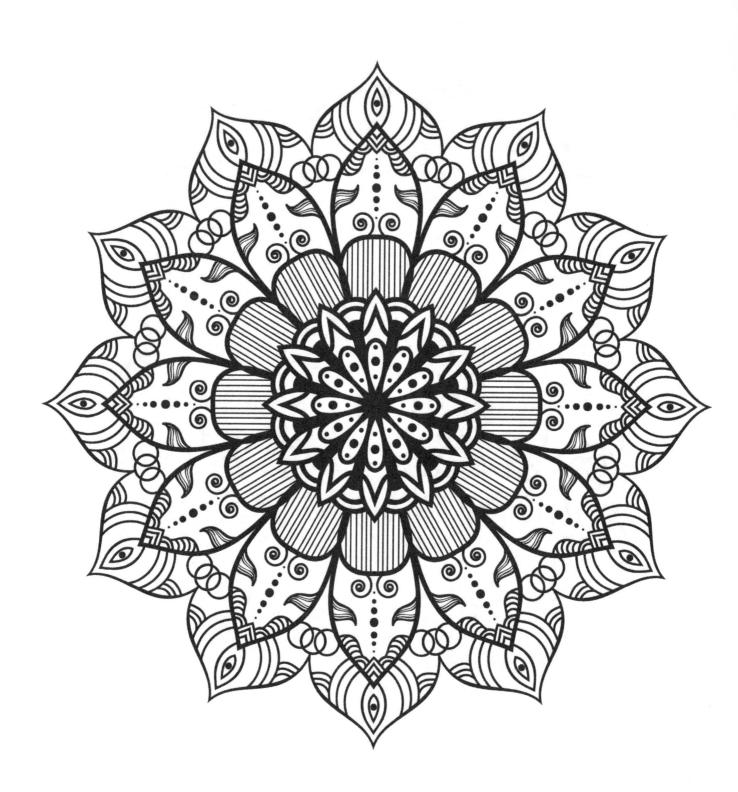

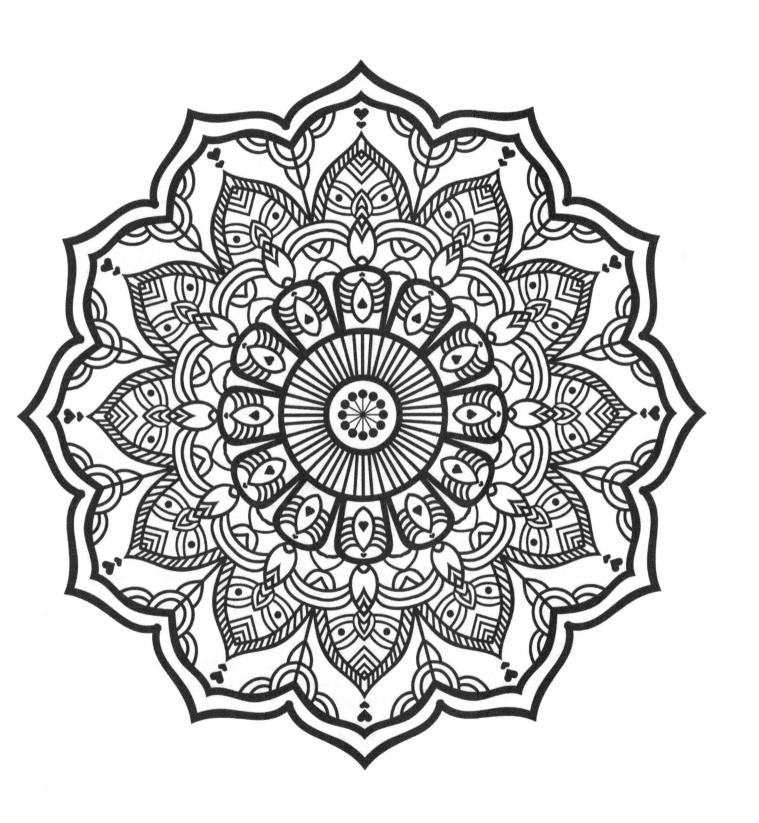

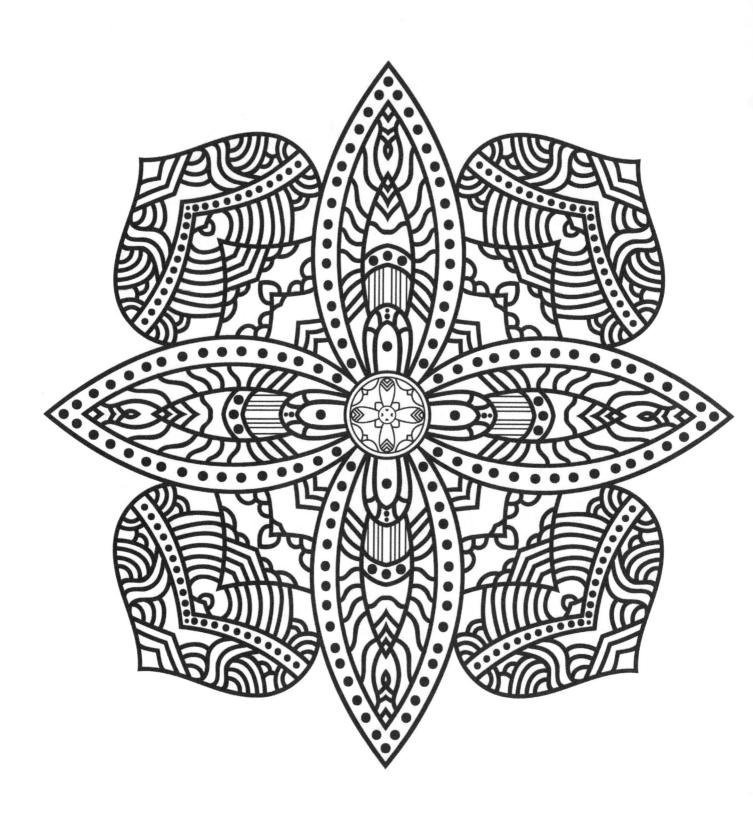

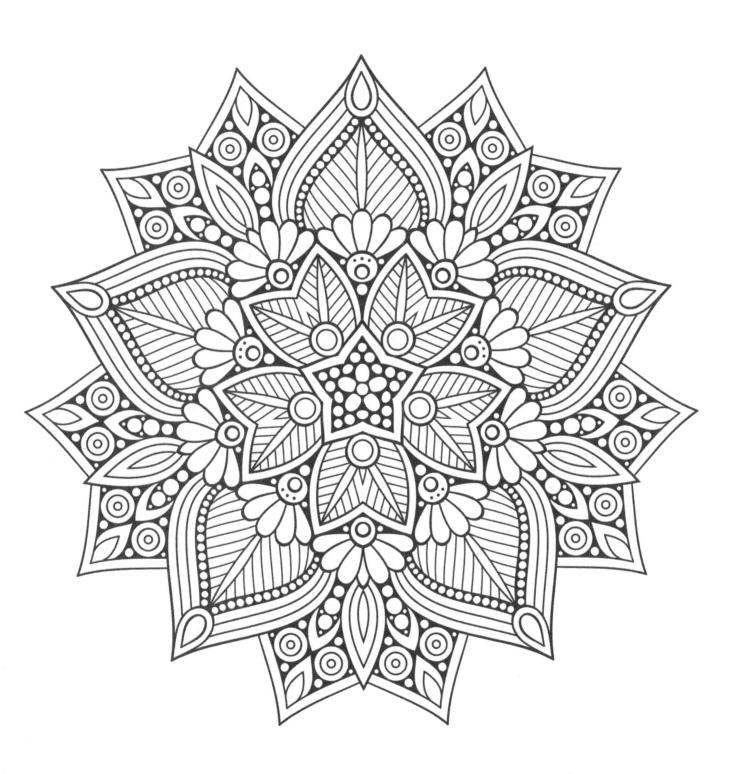

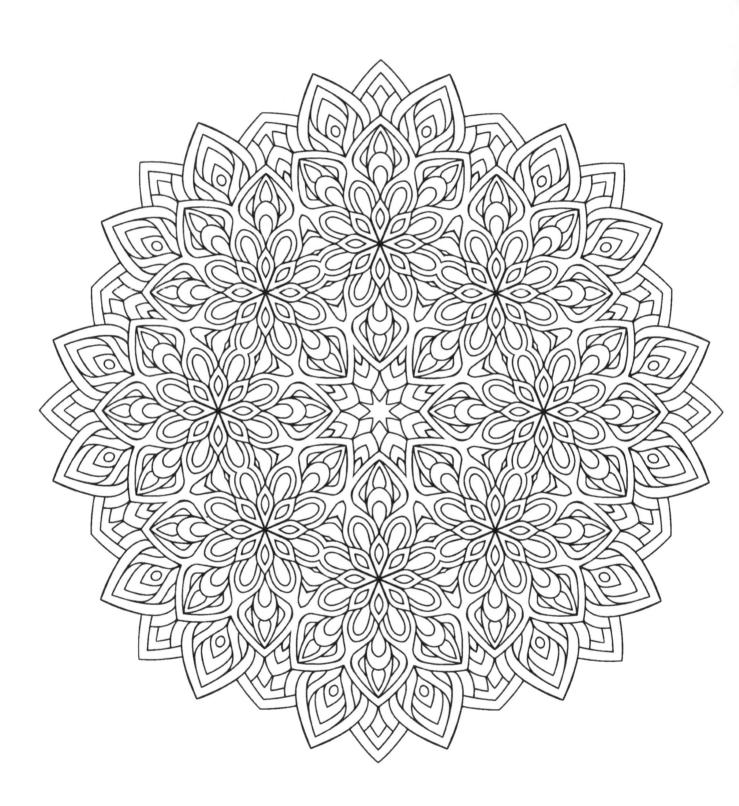

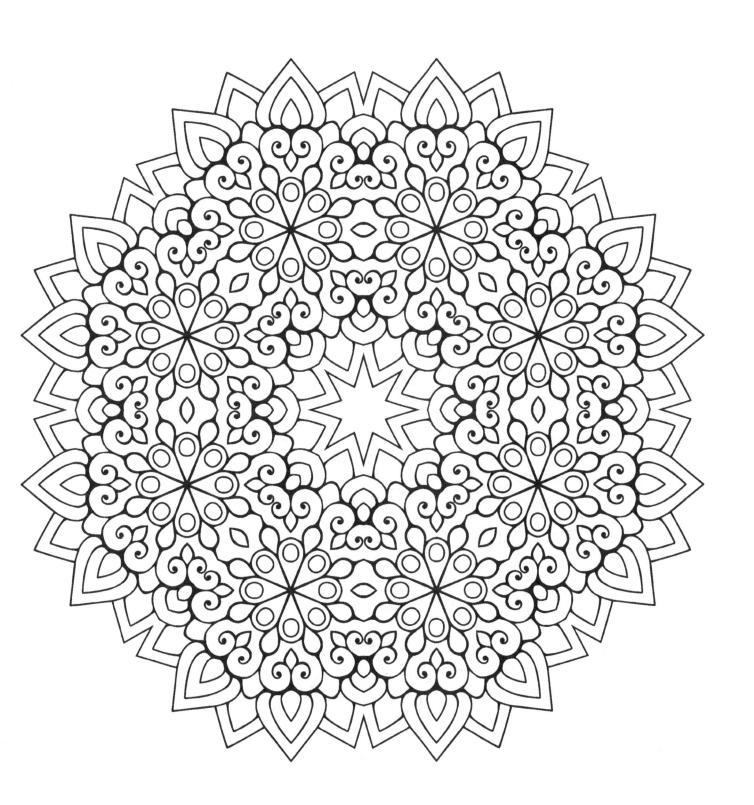

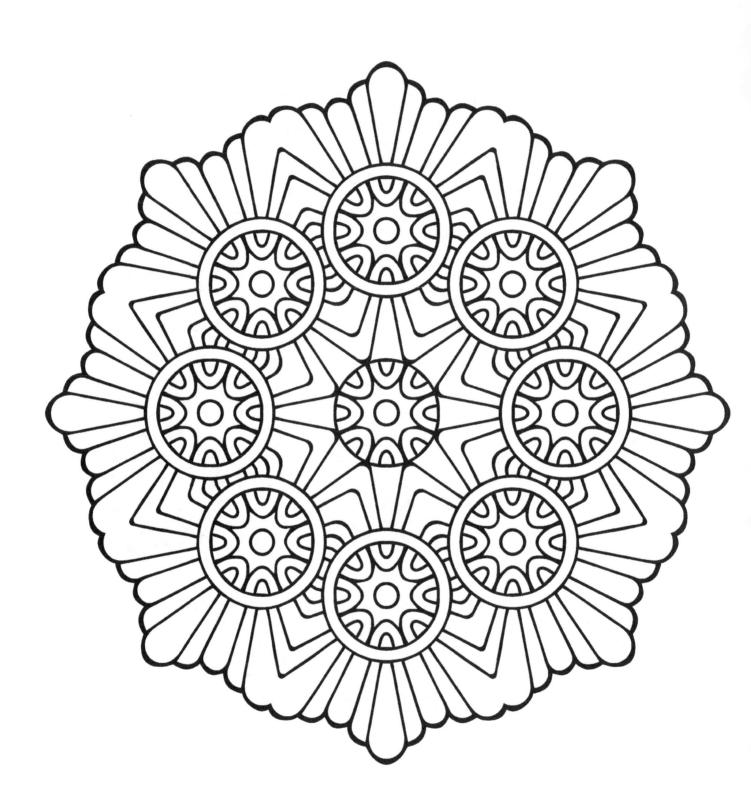

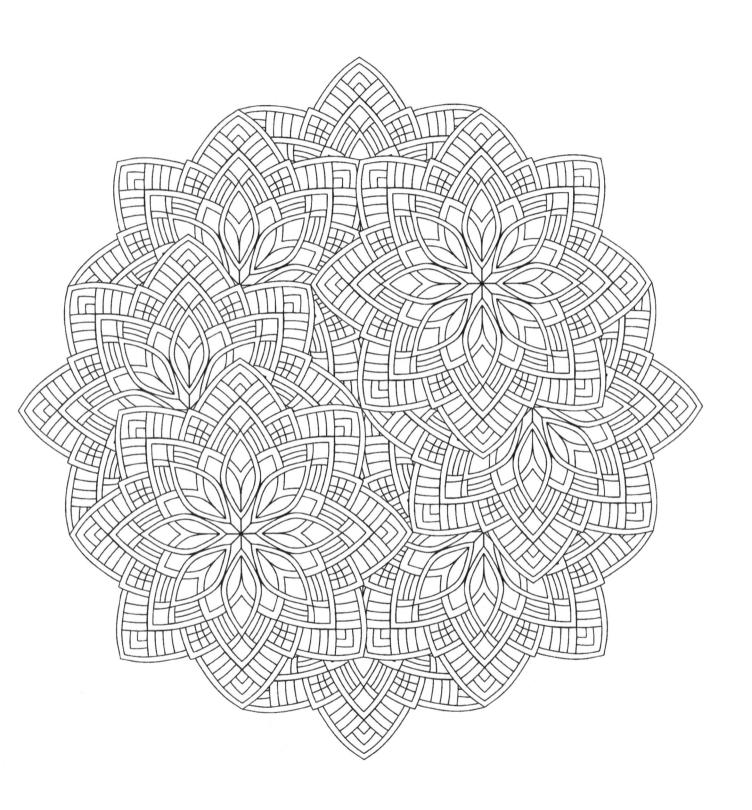

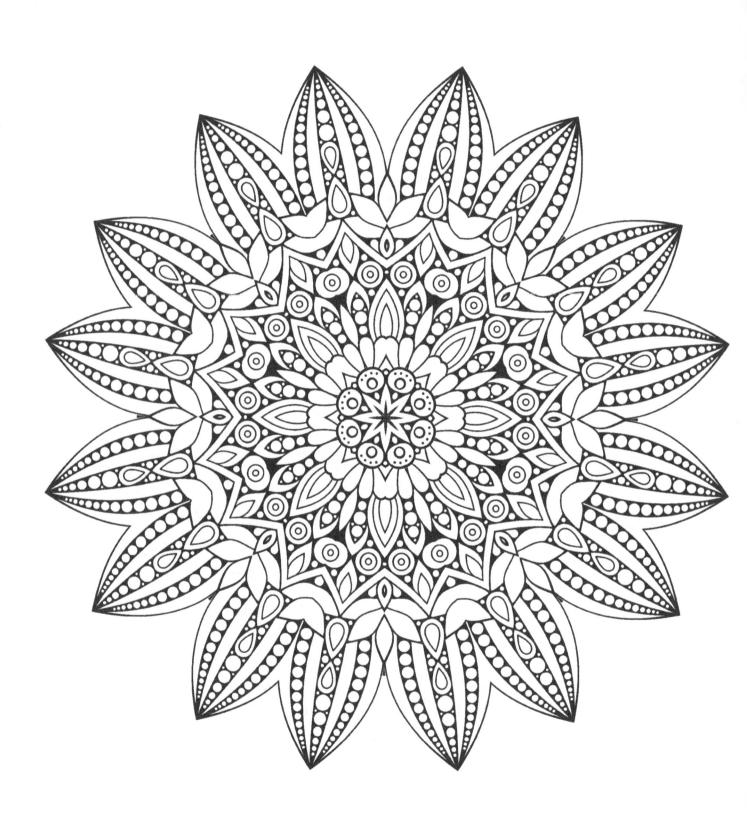

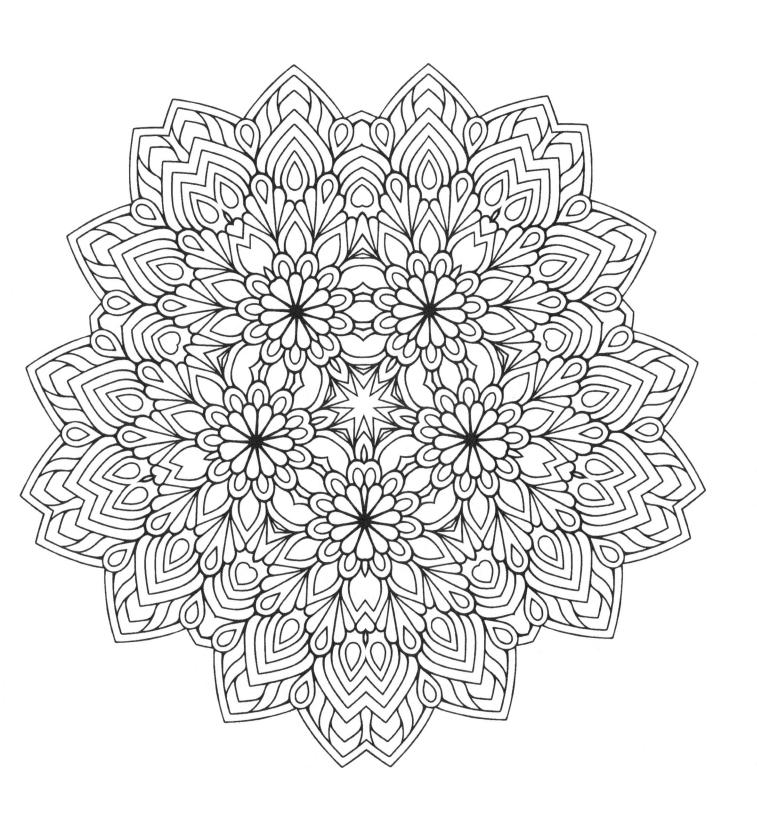

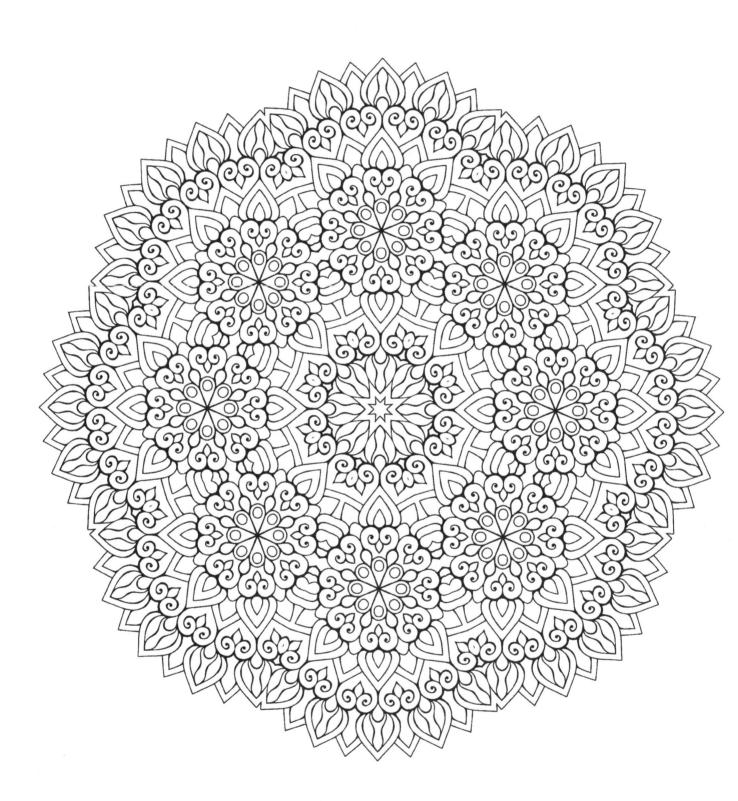

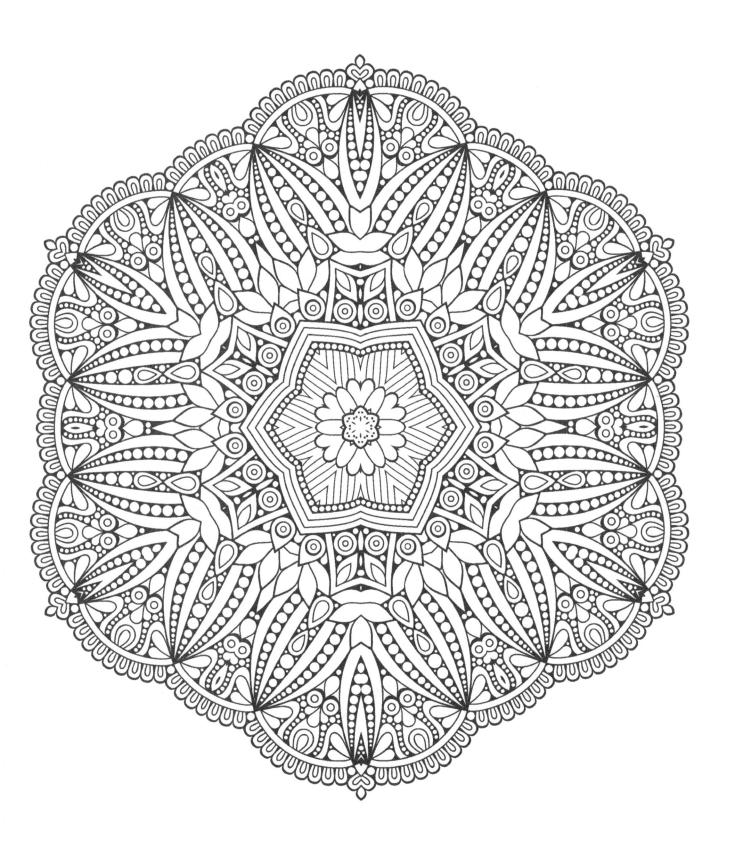

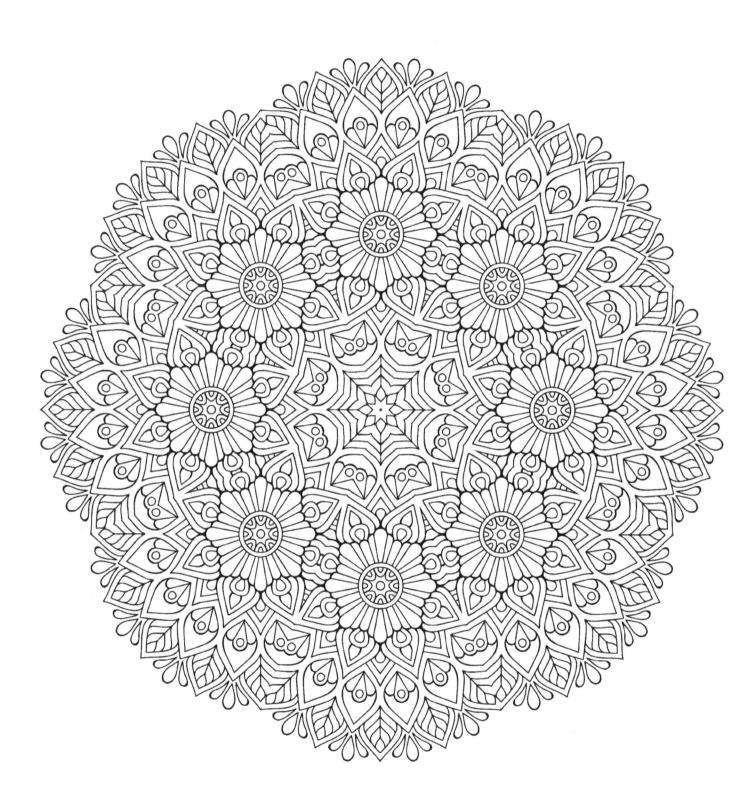

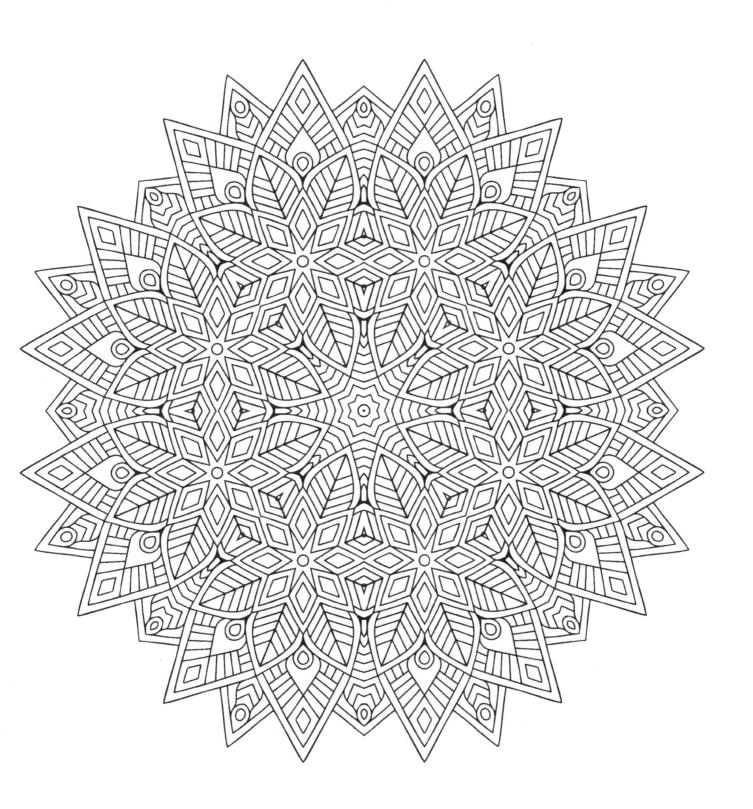

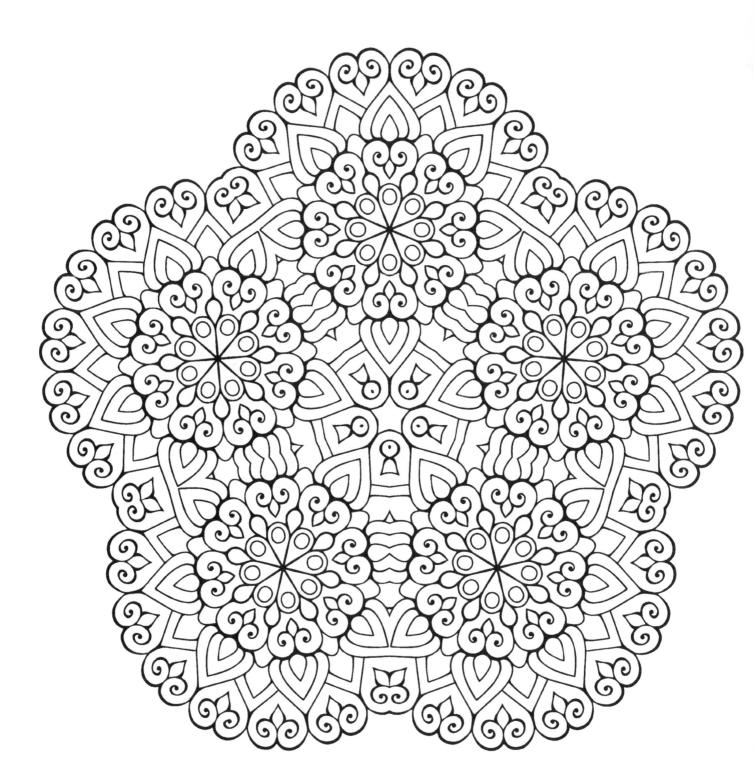

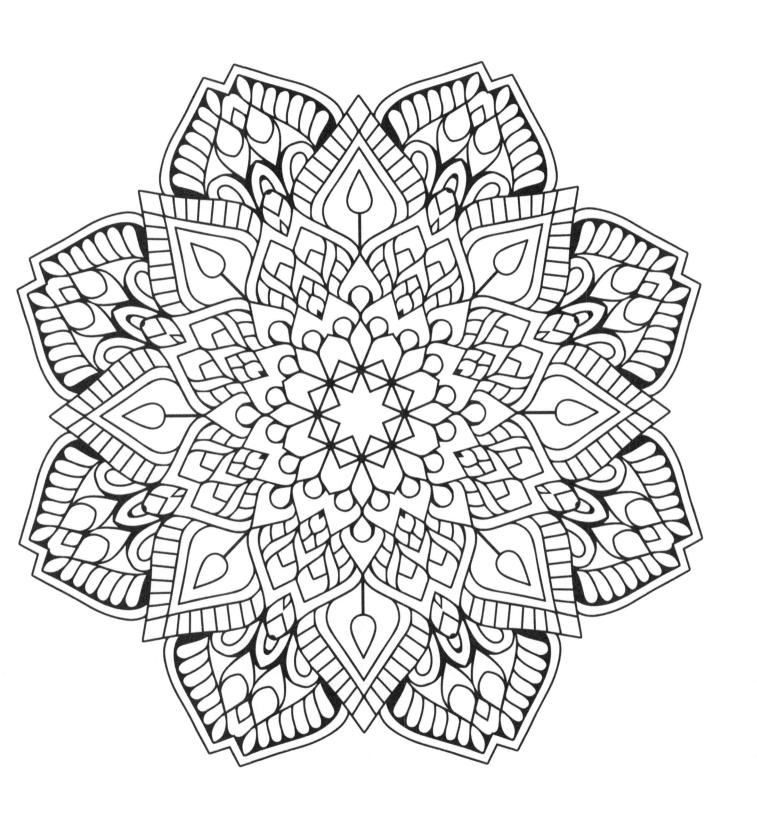

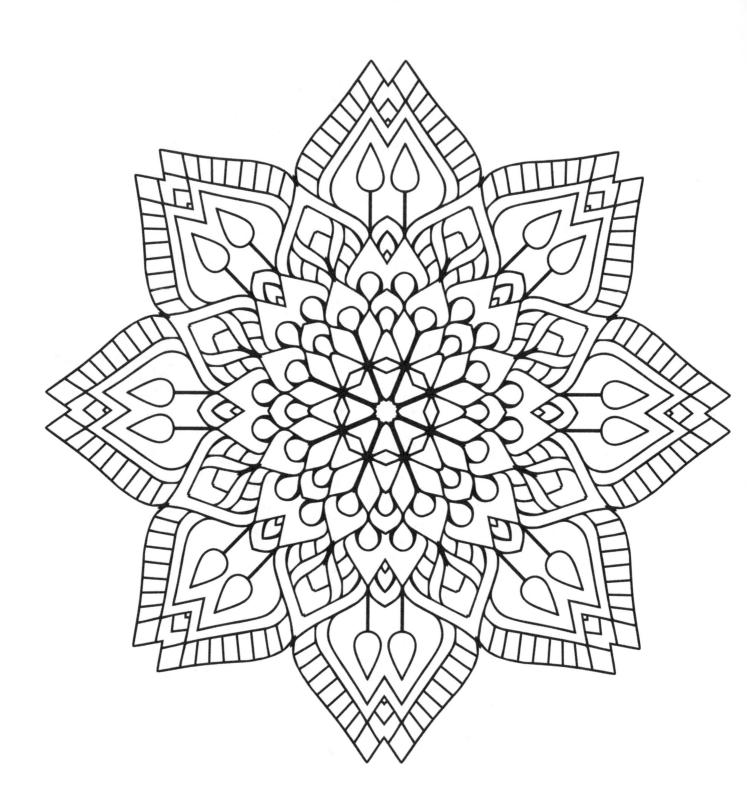

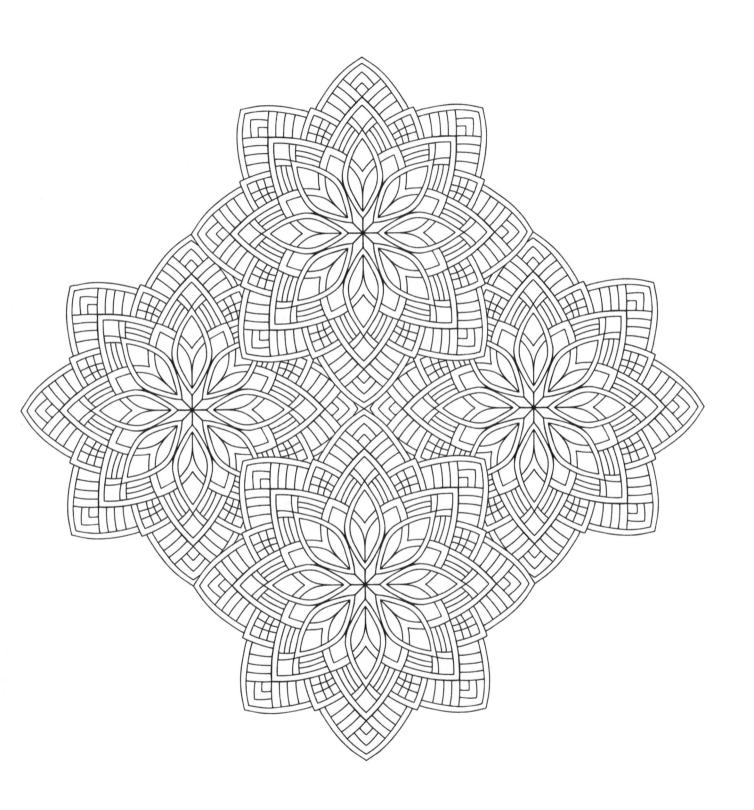

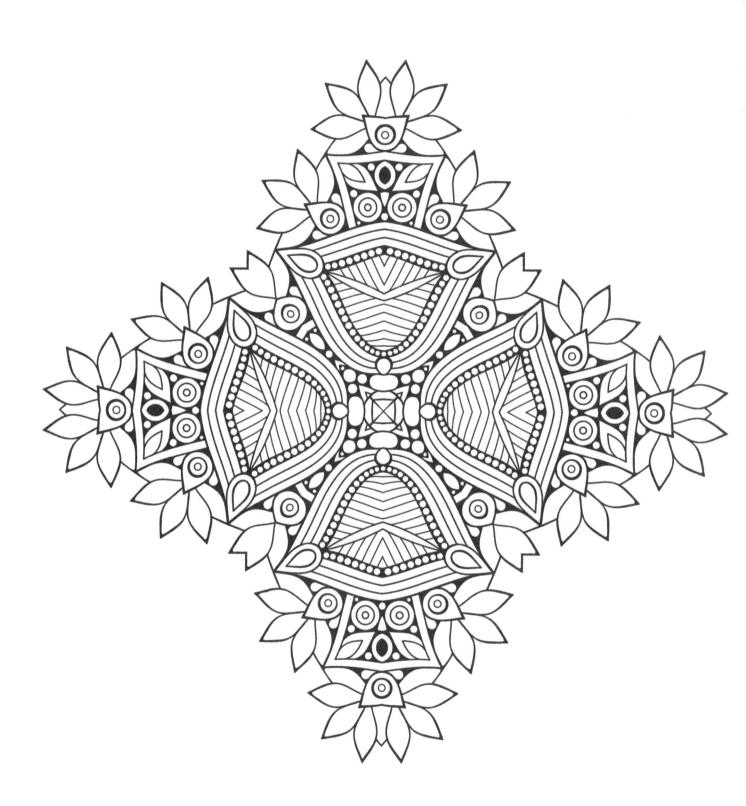

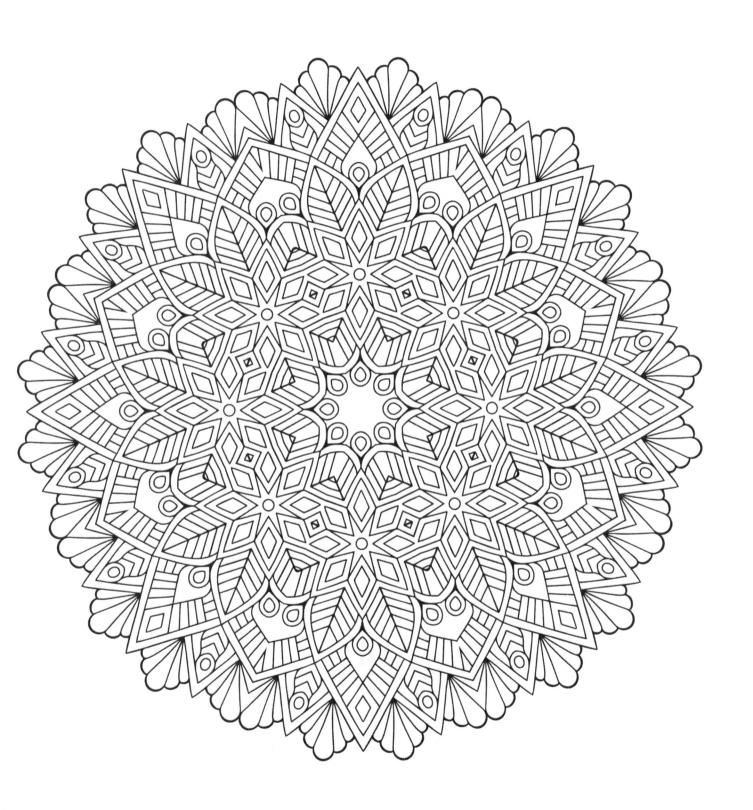

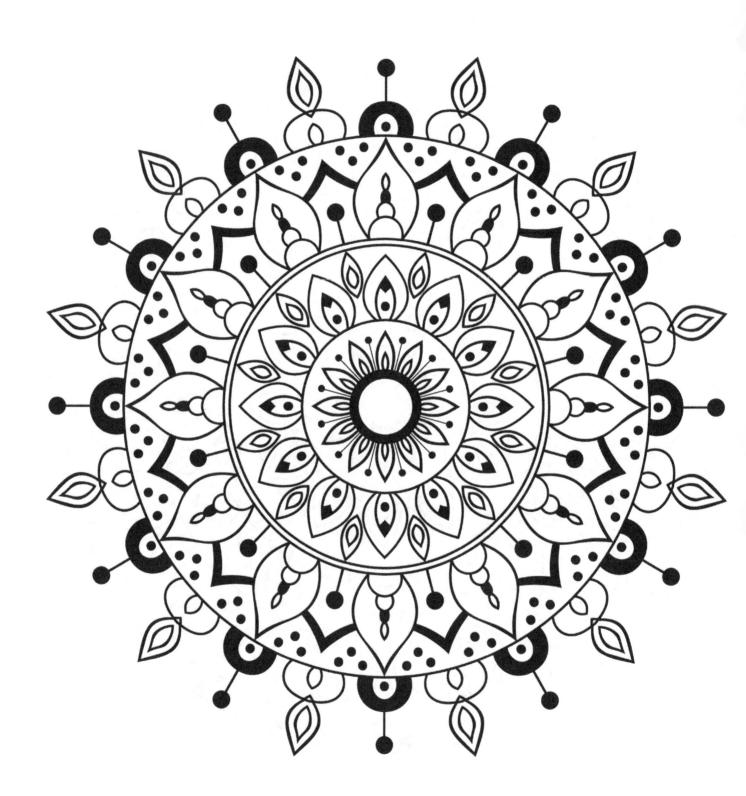

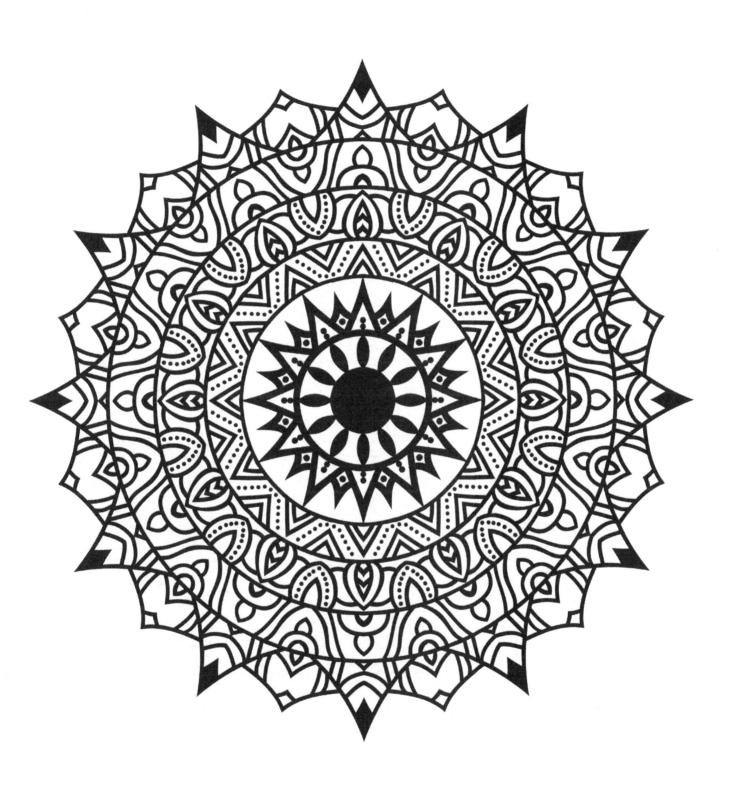

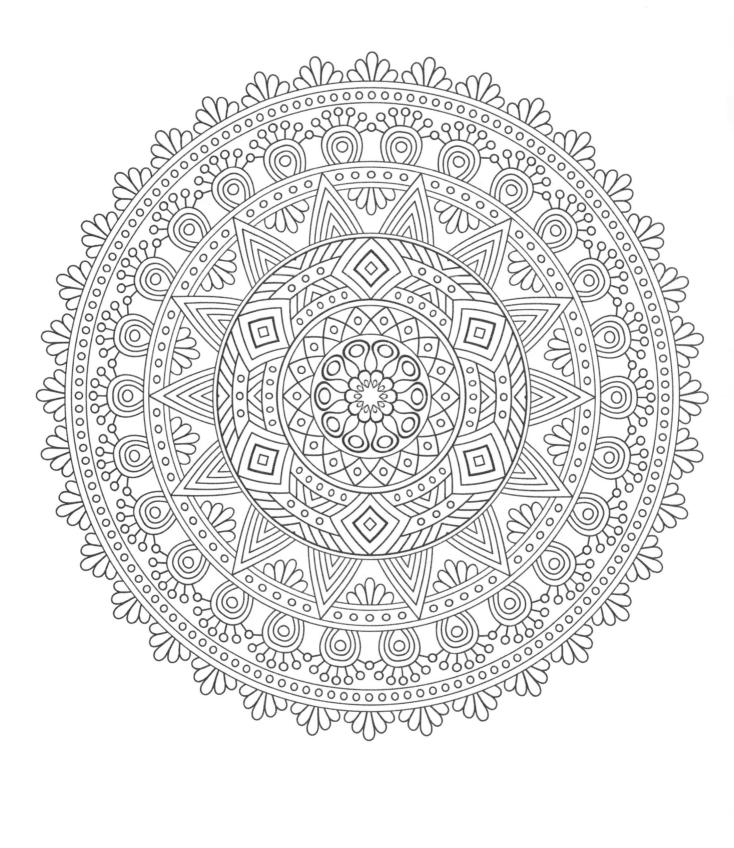

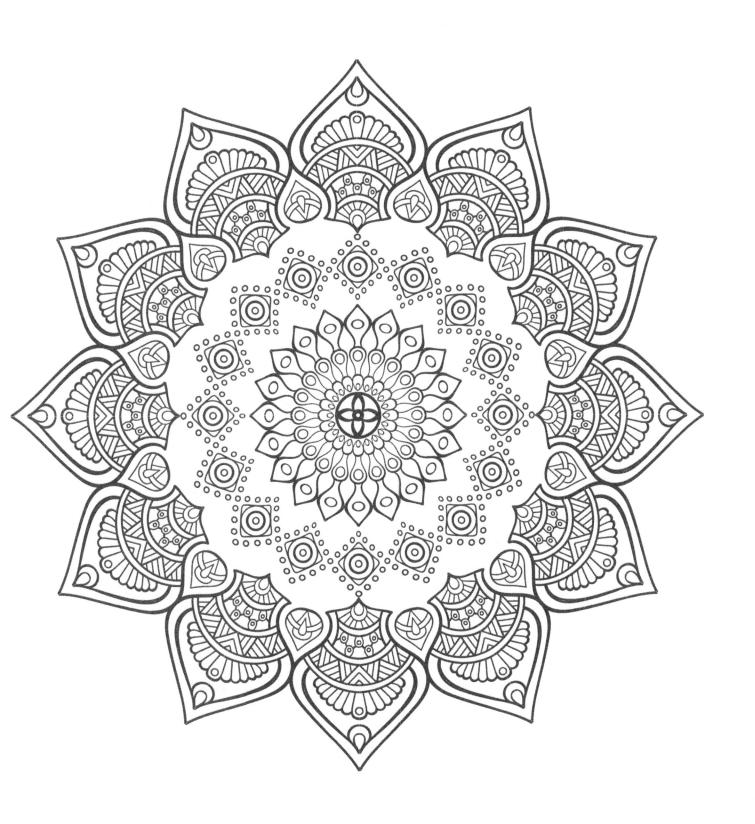

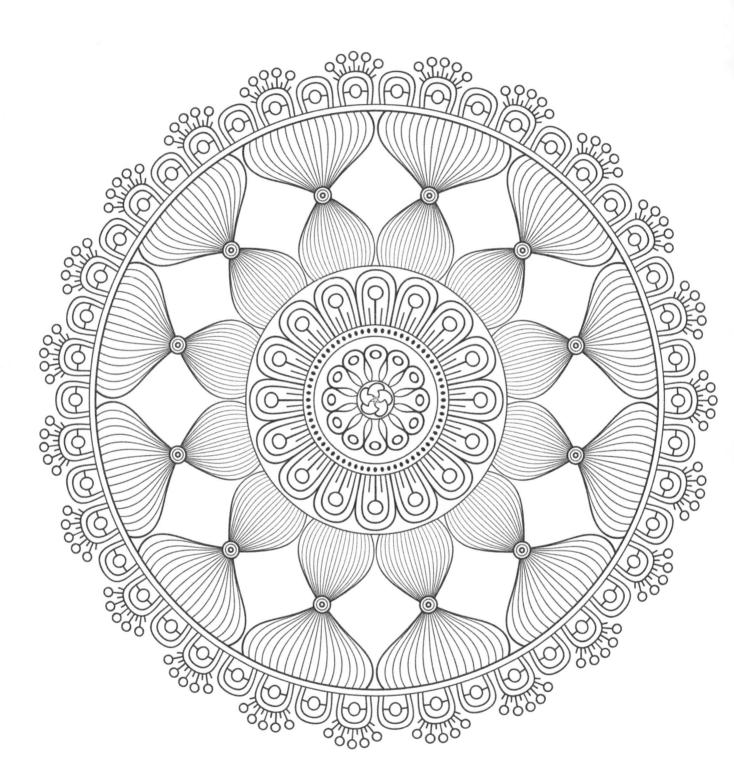

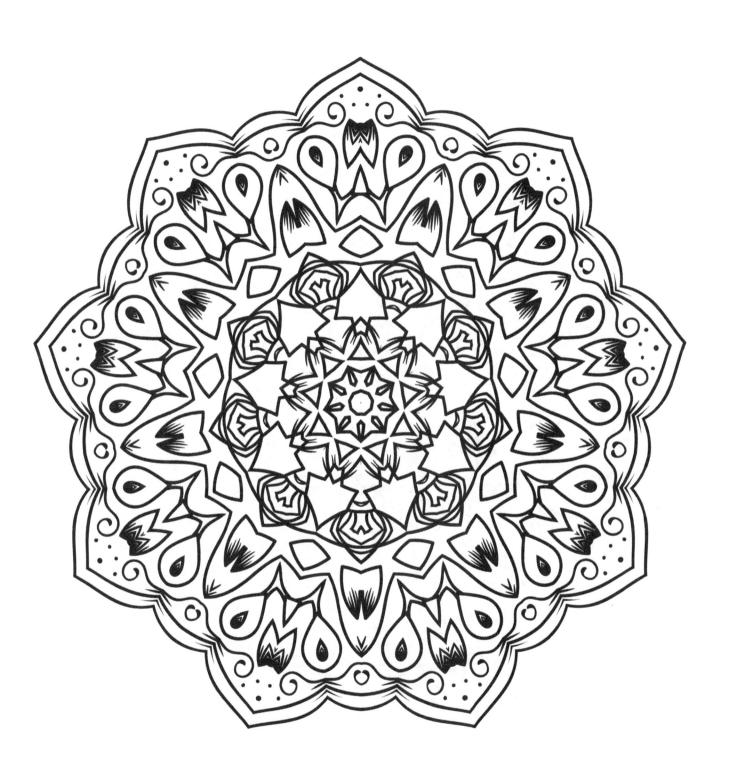

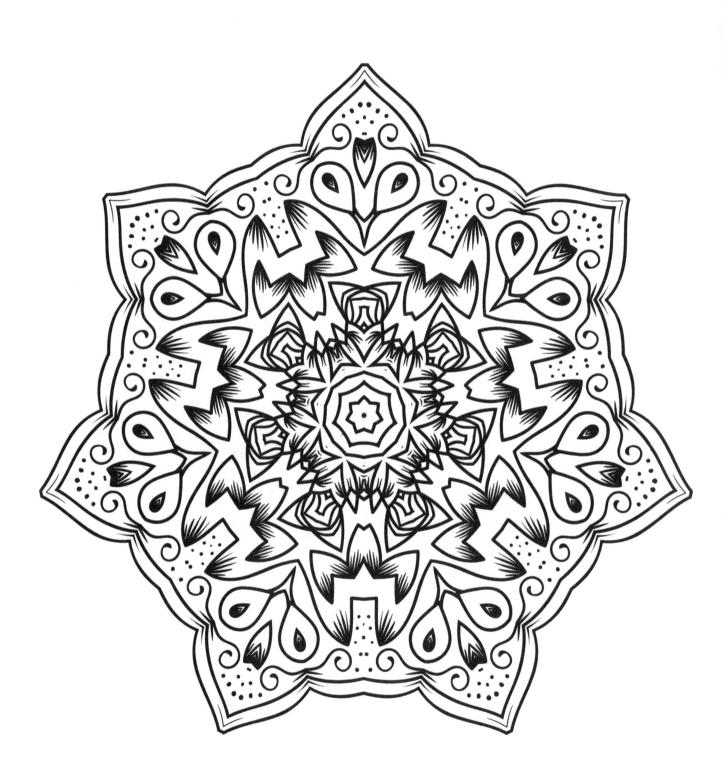

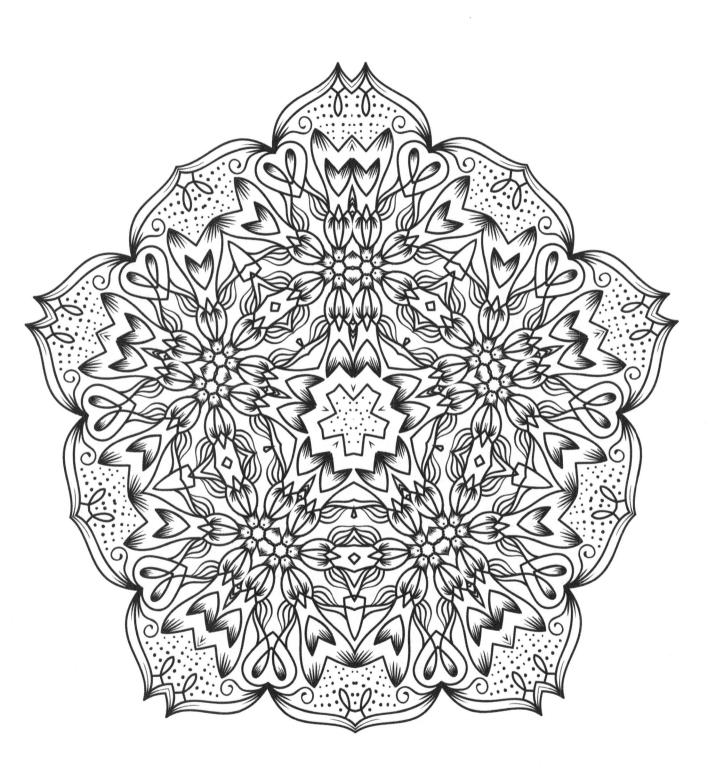

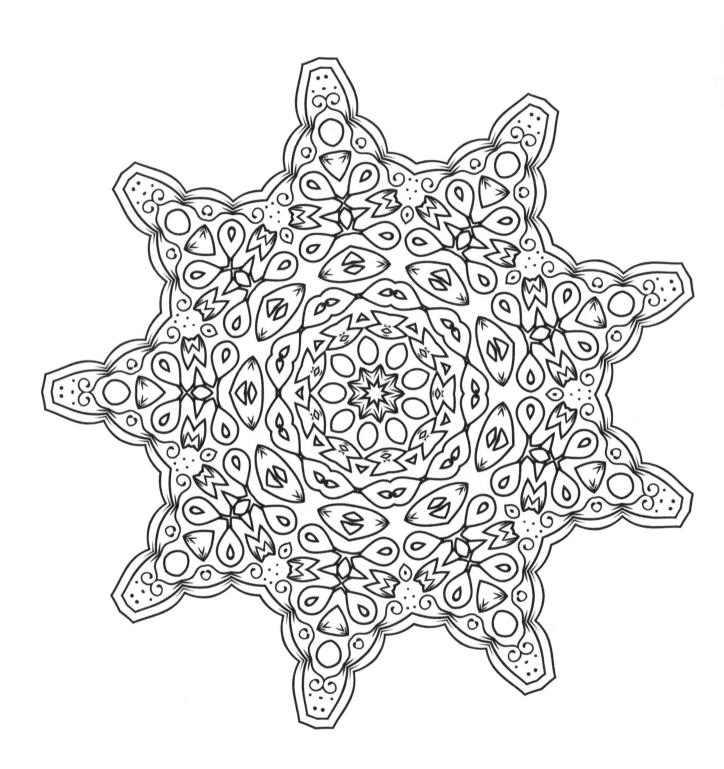

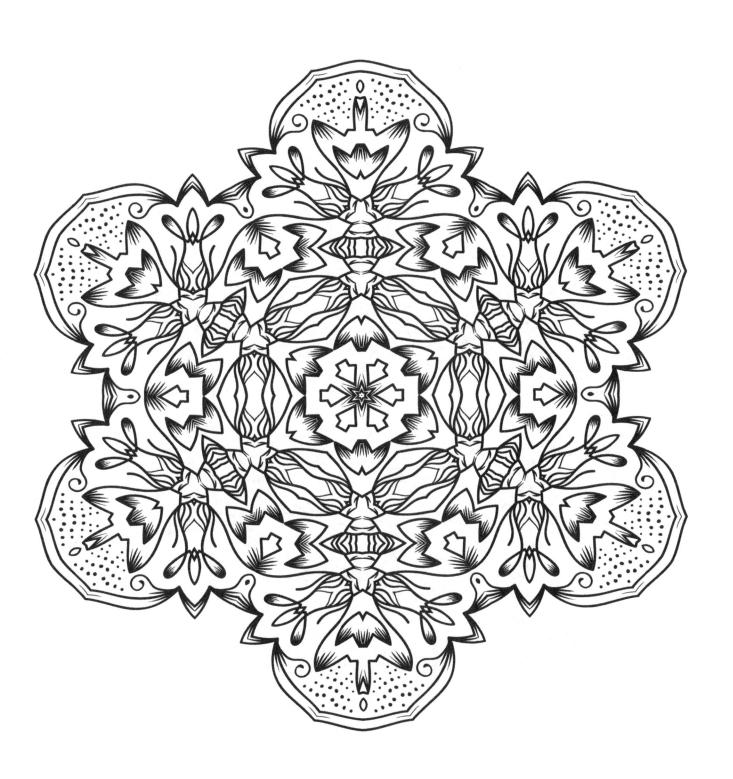

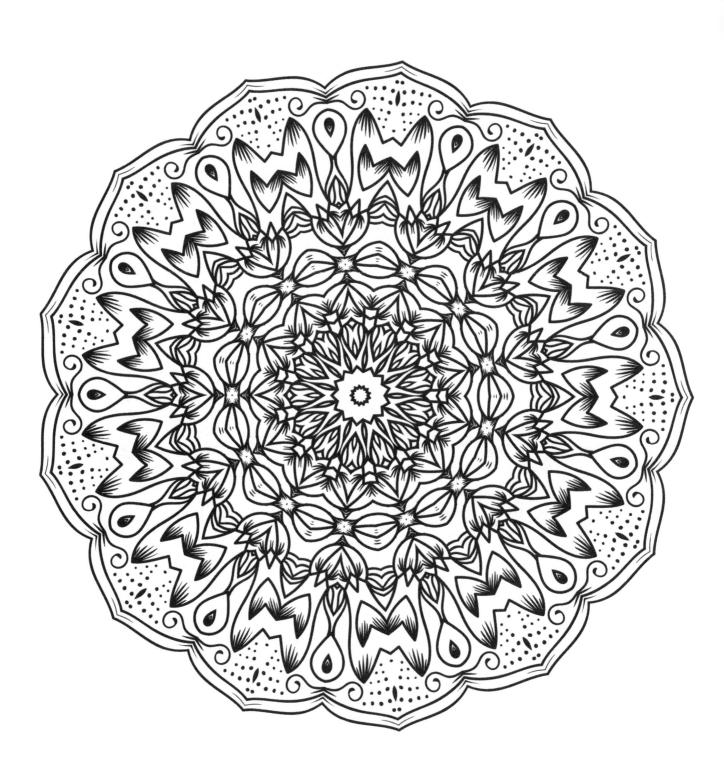

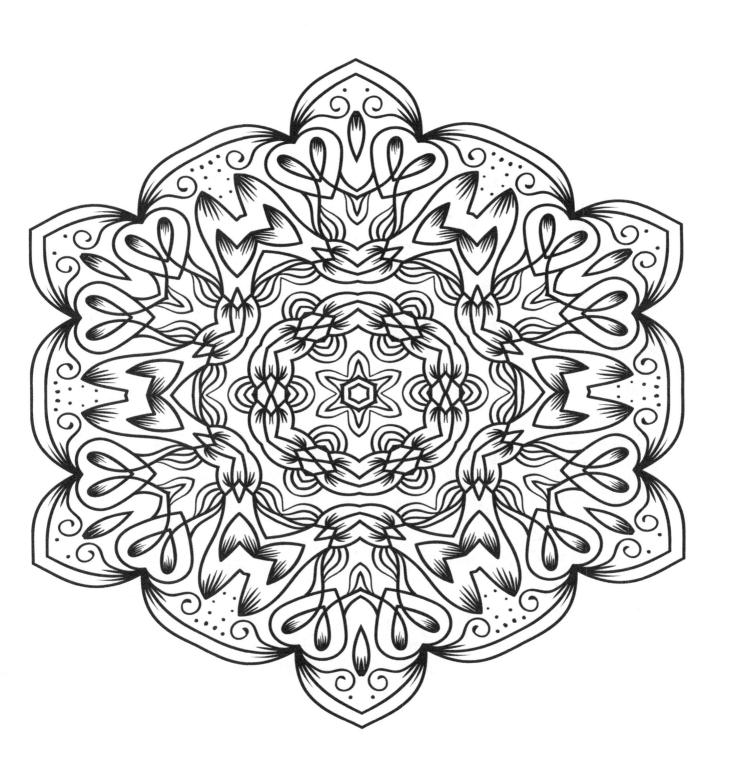

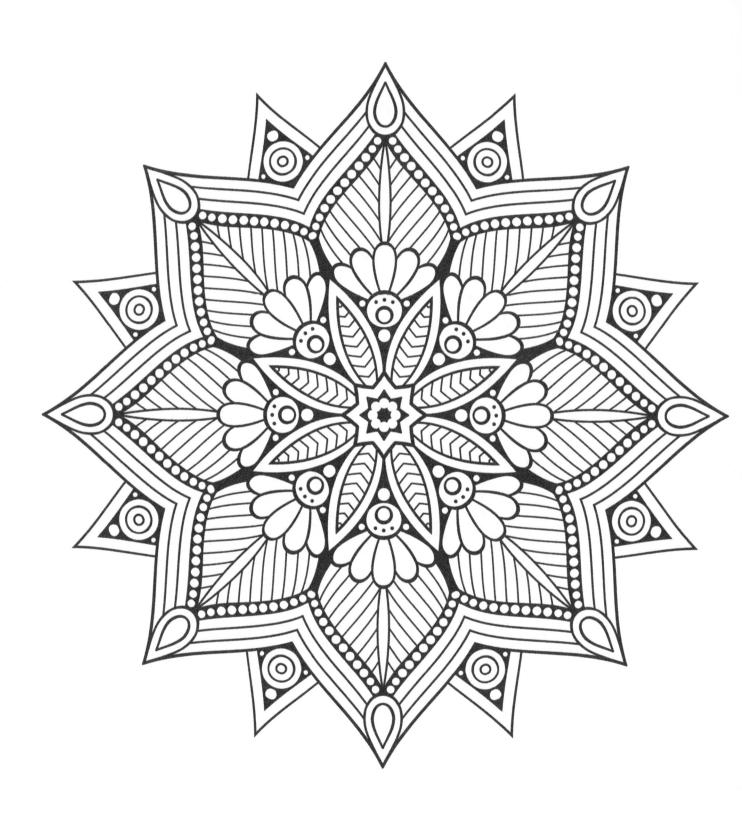

Made in the USA Las Vegas, NV 03 April 2024

87886324R00085